Norfolk Country Houses

FROM THE AIR

Picture credits

All photographs © 2015 MIke Page

Norfolk Country Houses

FROM THE AIR

Aerial photography by Mike Page
Text by Pauline Young

POPPYLAND
PUBLISHING

Introduction

We are lucky to have so many interesting houses in this county, we are unlucky to have lost so many. From the fortified houses with defensive moats up to the ultra modern this book catalogues domestic building style throughout the centuries with the odd really grand (Blickling, Holkham,Houghton) thrown in. With the exception of a carstone quarry in north west Norfolk, the lack of a durable building material other than flint, together with the manufacture on site of local bricks has resulted in distinct local styles with only the very rich affording materials brought in from outside the region. And when stone *was* brought in, for example from Barnack in Northamptonshire or in the case of Norwich Cathedral from Caen in Normandy, water was the practical form of transport. In Norfolk we have water in abundance via the Fens & Kings Lynn or via the Broads and Great Yarmouth. One of the great advantages of aerial photography is that the surrounding land or garden also can be appreciated and the house seen in context. The houses in this book make up a visual feast. Enjoy.

Mike Page Pauline Young
Strumpshaw Wymondham

The Country Houses

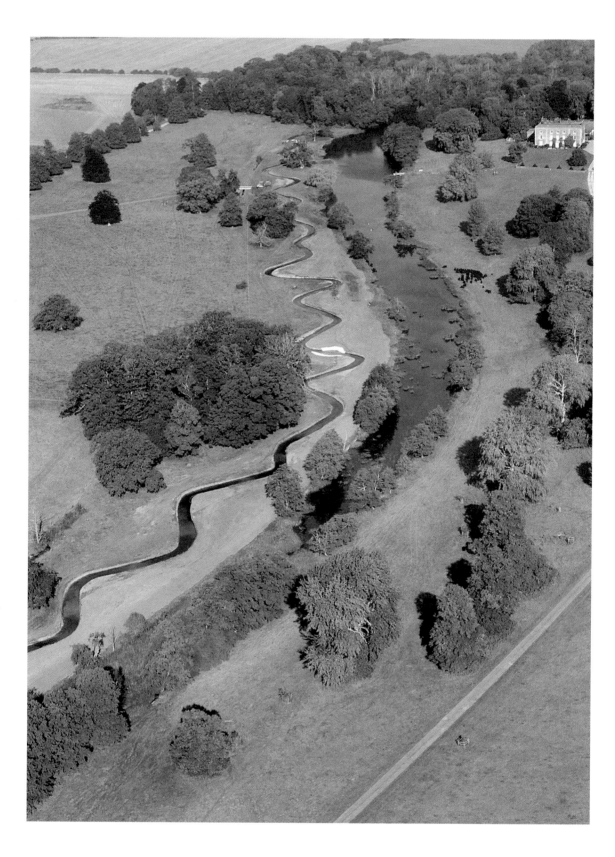

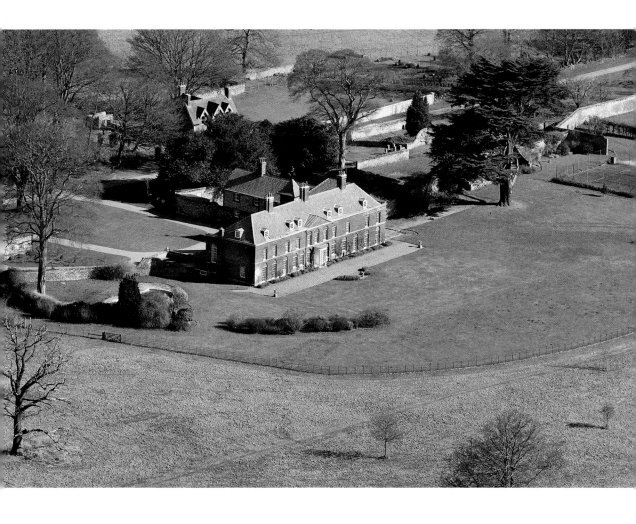

ANMER HALL

This late Georgian hall on the Sandringham Estate was built around an earlier dwelling. Architectural historian Sir Roy Strong describes the house as 'a comfortable, unpretentious Georgian building'. Recent renovations have included the new roof. The tower (just visible behind the roofline) is of carstone, a ginger coloured limestone quarried in north west Norfolk . Sandringham Church is a fine example of the use this stone.

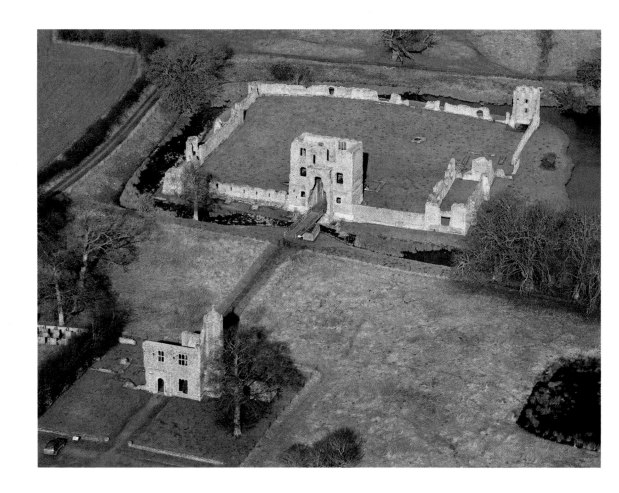

BACONSTHORPE CASTLE

The powerful landowners of Norfolk (some of whose ancestors came over with William the Conqueror) were subject to rivalry and squabbles among themselves and tried to make their dwellings impregnable, hence the defensive moats and gatehouses of the 13th, 14th and 15th centuries. There are several such dwellings mentioned in this book; the moat is a clue. This castle was built by the influential Bacon family. Whilst most of the castle buildings had to be demolished in the 16th century to pay off debts, the gatehouse survives. Baconsthorpe Hall was lived in until the 1920s when a turret collapsed and the building was abandoned. It is worth the drive along the long bumpy farmland track near Holt to experience the atmosphere these ruins generate.

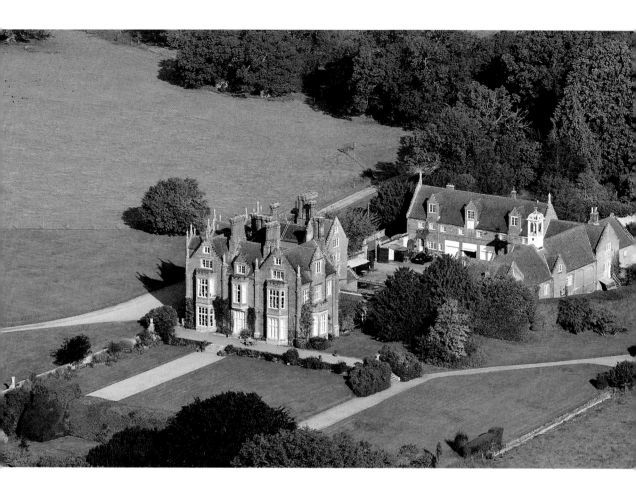

BARNINGHAM HALL

This hall is in the delightfully named Barningham Winter after a knight of 1410, John Wynter. His brass memorial hangs on the wall of the church entrance . The hall is older than at first it appears to be. It was built by a member of the Paston family in 1612. In 1805 the then new owner asked Humphrey Repton to remodel the house which at the time 'did not contain one room that was comfortable'; clearly he succeeded because the family is there still.

The part ruined church of St Mary stands in the grounds, the chancel now serves as the parish church.

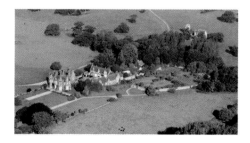

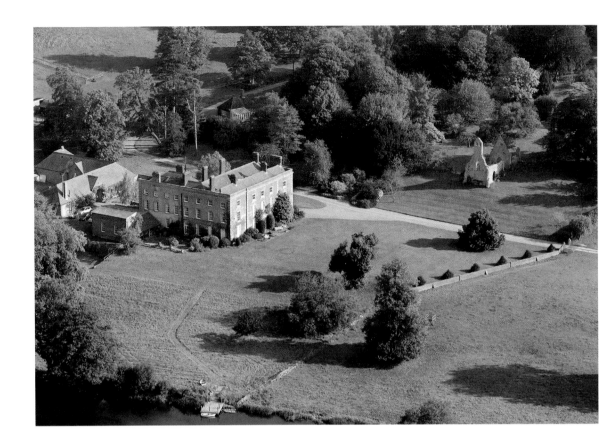

BAYFIELD HALL

The Elizabethan Hall of the Jermy family was acquired by the Jodrells in the 18th century, a descendant of whom gave his name to the telescope at Jodrell Bank.

On page eight you can see the River Glaven as it winds its way to its mouth at Cley, passing Bayfield Hall on the way.

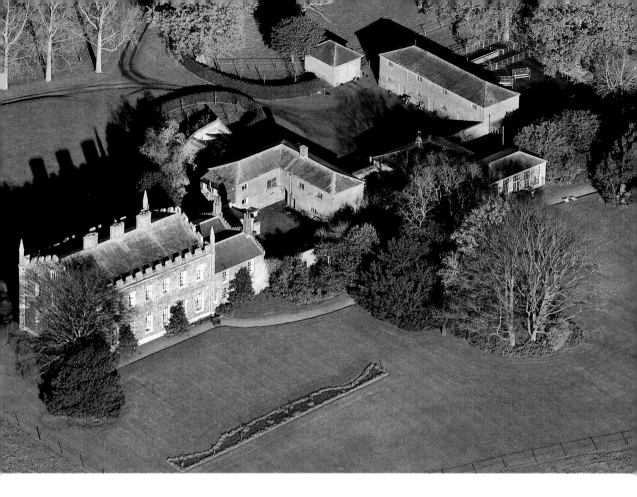

BEESTON HALL

There are three Beestons in Norfolk, this one is Beeston St Lawrence (or Laurence), near Wroxham. Built in 1786 of squared knapped flints, and castellated, the hall is an early example of the Gothic Revival in the county. The castellation served merely as decoration or fashion because the age of fortified houses was long past when this house was built. The 'tun' part of the name Beeston indicates it was a place where reeds and rushes grew and certainly there's a lake nearby.

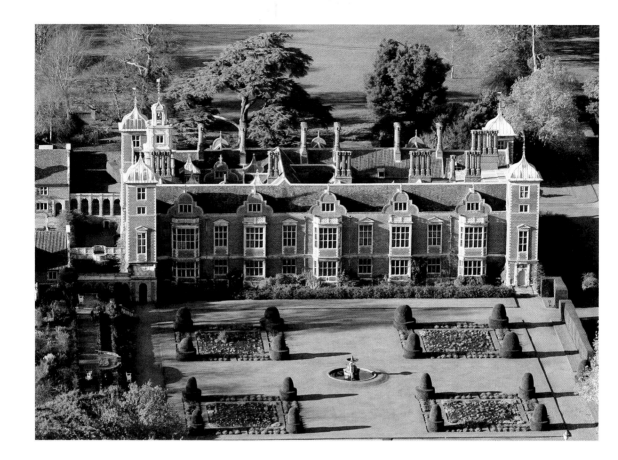

BLICKLING HALL

Blickling is the jewel in the National Trust's East Anglian crown, magnificent by any standards. Built in the years 1616-27 for the then Lord Chief Justice, Sir Henry Hobart, it was on the site of an earlier house. Pevsner describes it as one of the major Jacobean houses in England. As with many building projects large and small the budget overran and when the west side was rebuilt in 1769 the then owner's wife, the Countess of Buckinghamshire, bequeathed all her jewels to pay for the alterations. What makes Blickling visually particularly attractive is the choice of building materials. Instead of choosing the more formal stone, imported to the region because most of Norfolk has no stone suitable for construction, a million and a quarter locally made red bricks gives a warmer feel to the whole.

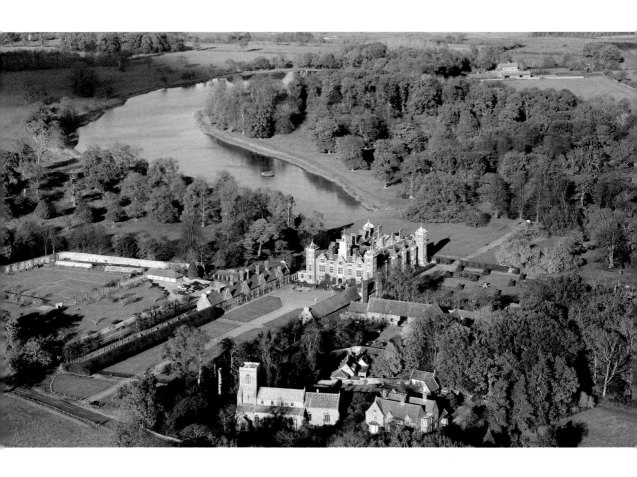

BLICKLING

The stable block to the left of the house now houses the offices. Formal gardens have been added and also a mausoleum (off picture). There is the suggestion of a moat by the front door, fed no doubt by the almost regulation lake.

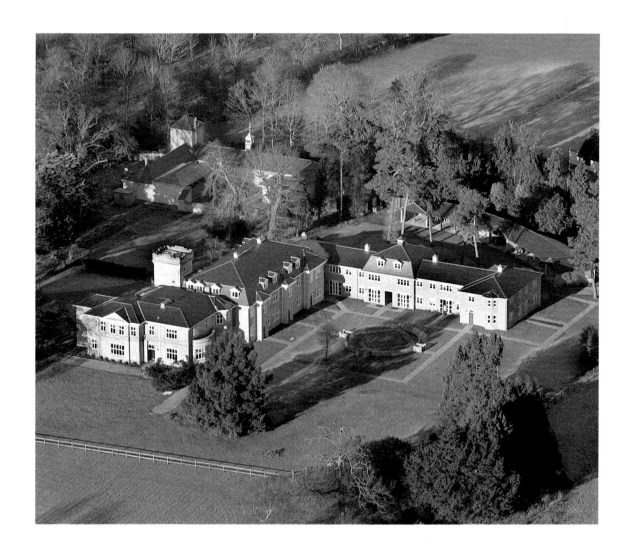

BLOFIELD HALL

Elegant apartments turn what might have become a white elephant into a pleasant place to live.

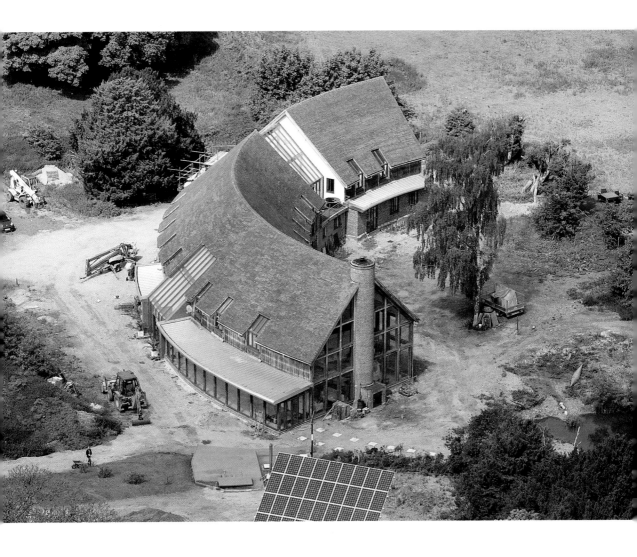

BOYLAND HALL

The original 19th century south Norfolk Boyland Hall was demolished in the 1940s. The new Boyland Hall has been 5 years in the build but is now nearing completion. Using photovoltaic solar panels and its own spring-fed water supply the aim is to be self sufficient, a concept which the hall's energetic owner will be employing in the gardens once the house is completed.

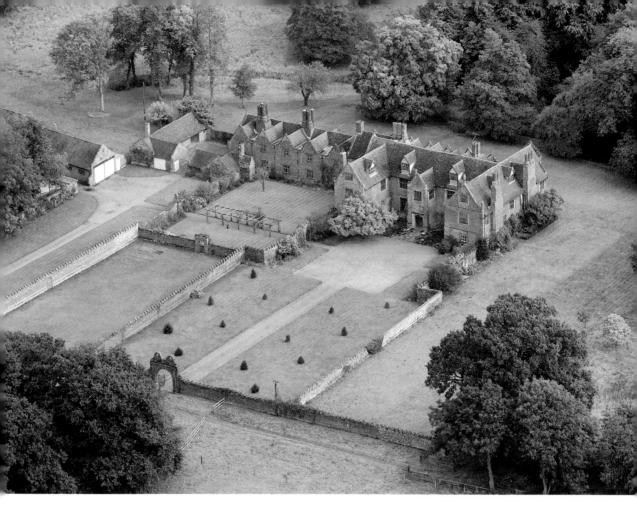

BRECKLES HALL

The moated Elizabethan Hall was built by the staunchly Catholic Wodehouse family about 1593, in the uncomfortable period during and post Reformation. Like similarly placed Oxburgh, a priest's hole was incorporated to hide the resident Catholic priest from discovery in the period of anti Catholicism during the reign of Elizabeth I.

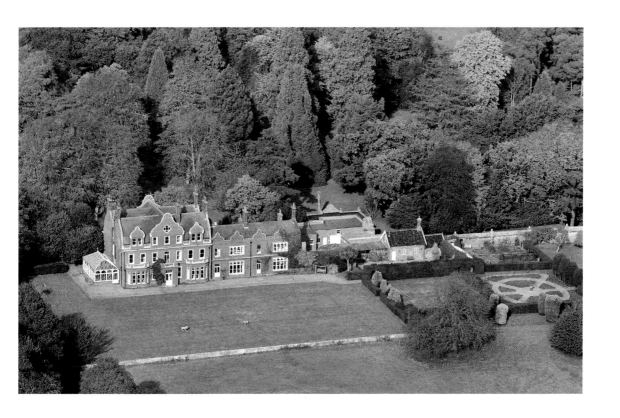

BROOME PLACE

Built around 1700 but considerably updated in 1887 by Norwich architect
Basil Cozens- Hardy.

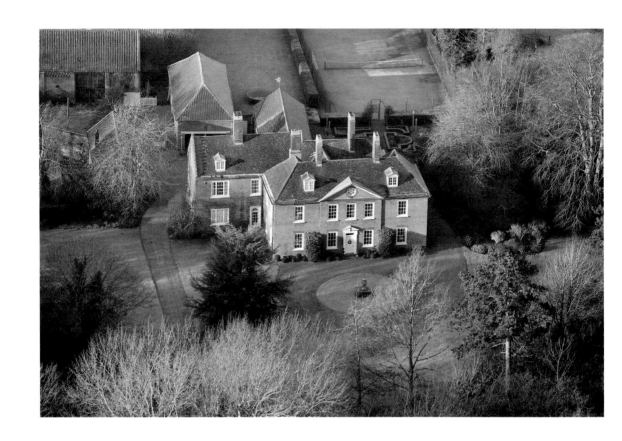

BURGHFIELD HALL

Burghfield was built around 1730 near Wymondham; it was enlarged a century later.

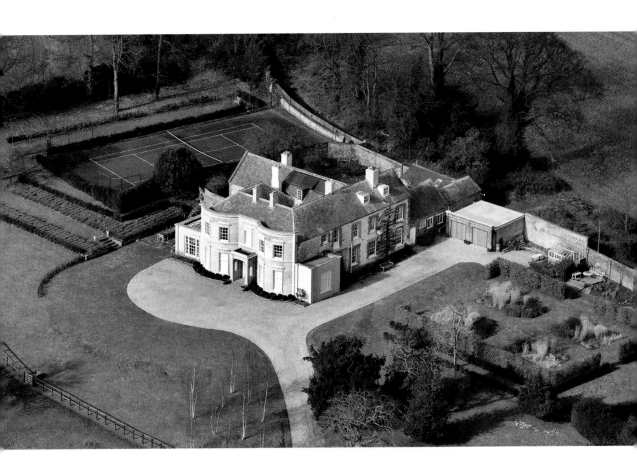

BURNHAM THORPE RECTORY

Sadly the rectory in which Horatio Nelson was born no longer stands, in fact the present elegant building doesn't even merit a mention by Pevsner.

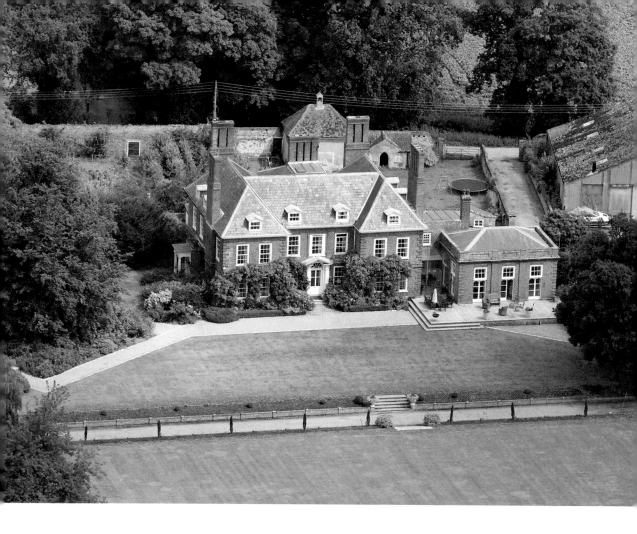

BURNLEY HALL (formerly **Somerton House**)

Built around 1700 in East Somerton, this is considered by Pevsner to be an extremely handsome house. In the grounds stands the ruined St Mary's church.

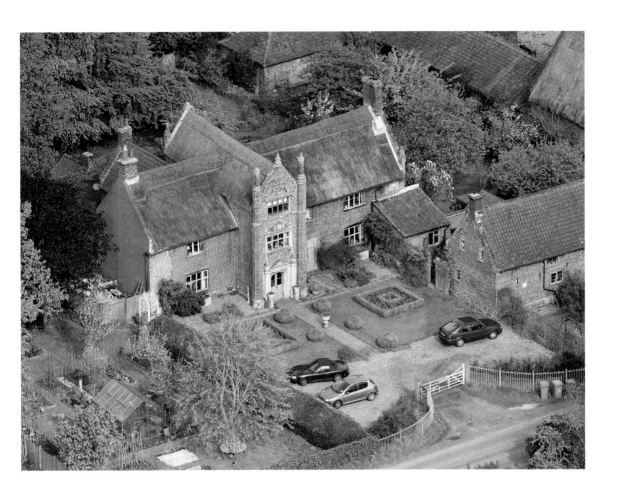

BURLINGHAM OLD HALL
aka SOUTH BURLINGHAM OLD HALL
aka BURLINGHAM ST EDMUND OLD HALL

This thatched farmhouse was built by an Elizabethan lawyer as his country retreat. Rescued from dereliction by the present owners, it can be visited on the annual Heritage Open Days or other times by arrangement.

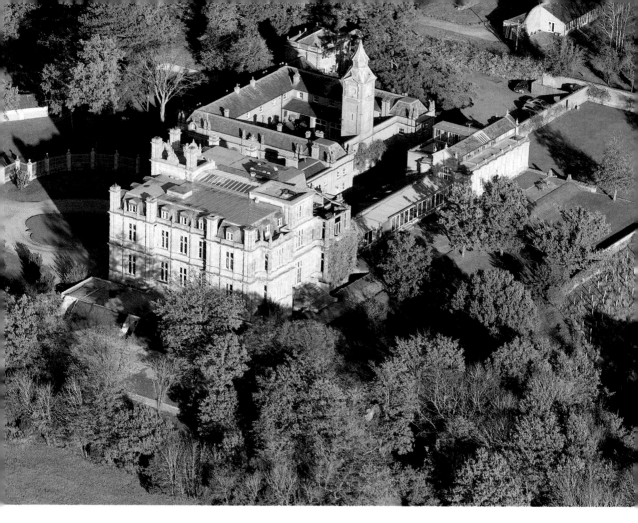

BYLAUGH HALL

Bylaugh (pronounced 'Beela') has been an unlucky house, especially in the last half century. Completed in 1852 at a cost of £29,389, it was the first building outside London to have a cast iron frame so that the stone cladding could be relatively lightweight. Never satisfactorily fulfilling the role of the intended grand country house, by the 1950s it was derelict. The orangery, stable block and some outbuildings were restored in 2002, the property changed ownership again in 2013 and now there is hope once more for restoration.

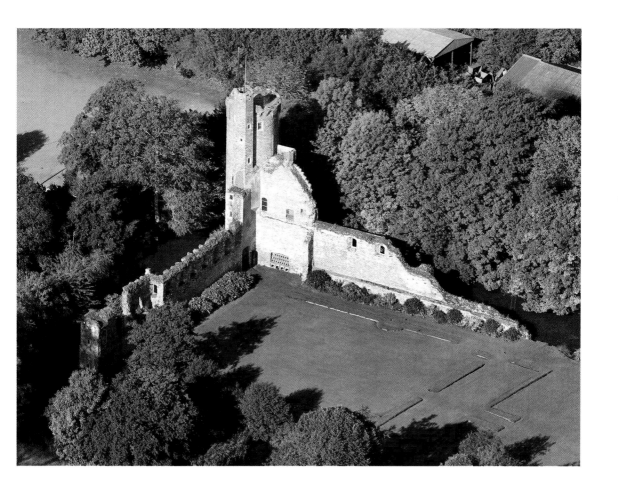

CAISTER CASTLE

Caister Castle was built by Sir John Fastolf (Shakespeare's Falstaff was alleged to have been modelled on him) with money acquired from the ransom of a French knight he had captured at Agincourt. Brick built and with the usual defensive moat, the property was later acquired by the influential Paston family as described in the 'Paston Letters'. The 98 feet high tower is fairly intact.

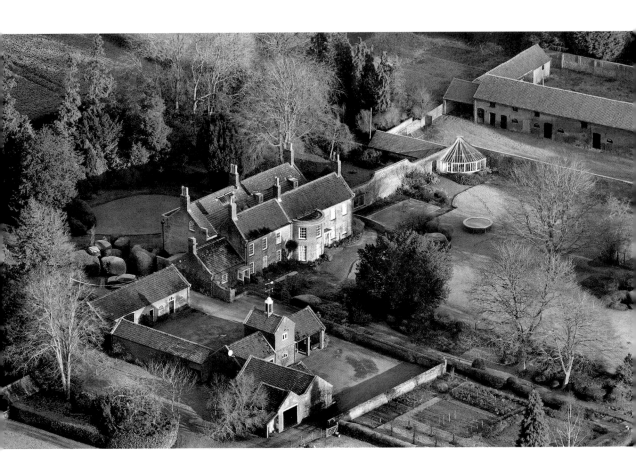

CARBROOKE HALL

For such a small village Carbrooke has a surprisingly large number of listed buildings. The build date of Carbrooke Hall is unknown but White's Norfolk 1845 states that 'the Hall was much enlarged 12 years ago' i.e.1833, by one Richard Dewing. In 1856 he built a tower mill in the village.

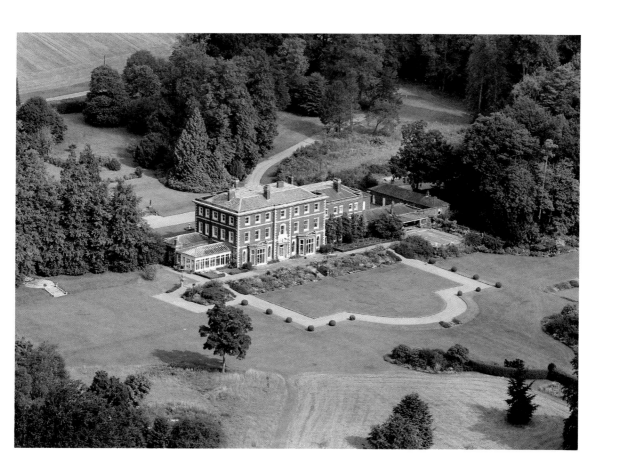

COCKLEY CLEY HALL

Cockley Cley Hall was built 1870-1 in the Italianate style.

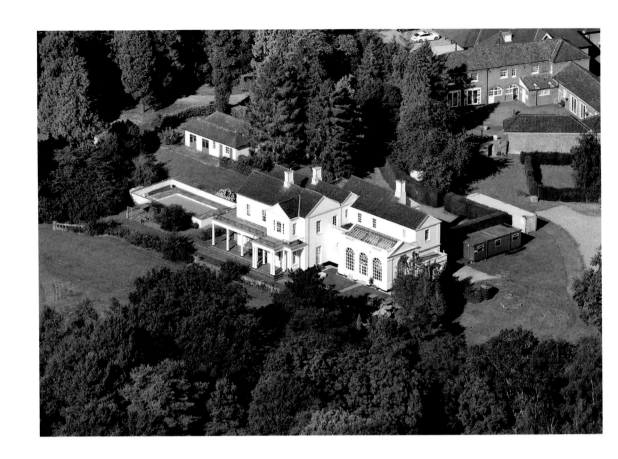

COLNEY HALL

Possibly built in the late 18th century, extended in the 19th and recently reduced drastically! The building is now a private medicine centre. The hall is a Grade II listed building, bought by Hugh Gurney Barclay in the late 19th century. The hall was well known at this time for its two lions - given to the family by a German count while the family were on holiday in Kenya.

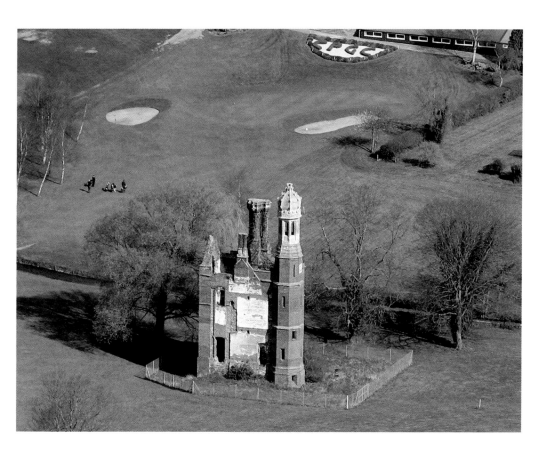

COSTESSEY HALL

This belfry is all that remains of Costessey Hall. The building dated back to Tudor times but was extended and remodelled into a Gothic style mansion in the 1820s. Many aspects of this extravagant new building contained elements of fantasy from the massive top-heavy crenellated tower to pinnacles in abundance on the roof line and tall decorated chimneys reaching for the sky. It was hardly surprising that the renovations resulted in financial disaster and in 1913 a sale of some of the contents took place. Further disaster in the shape of army occupation during WW1 left the house in a sorry state and in 1920 demolition began.

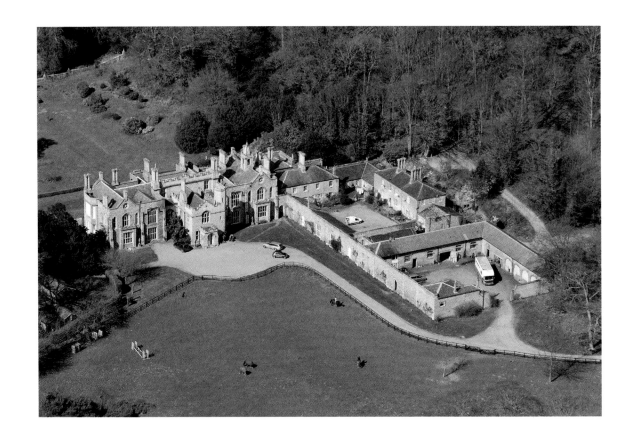

CROMER HALL

The present Cromer Hall was built 1828-1829 by Swaffham born William Donthorn on the site of a previous hall. Donthorn was architect of several Norfolk workhouses, possibly as commissions from Norfolk clients whose country houses he had already built such as Elmham and Watlingham Halls – now all demolished. Donthorn was the original architect of South Pickenham Hall and remodelled the interior of Felbrigg Hall. Cromer Hall is pleasingly built using the locally abundant material – flint – externally; the inside walls facing the courtyard are of red brick. The hall is often described as 'Tudor Gothic ' with high chimneys, stepped gables and an octagonal tower in the north west corner.

The inspiration for Conan Doyles' story 'The Hound of the Baskervilles' is claimed to have originated in a stay the writer made at Cromer Hall in 1901 where he heard the tale of Norfolk's Black Shuck, the ghostly black dog whose appearance is alleged to be a herald of death. Moreover the descriptions of the fictitious Baskerville Hall bear similarities with the external appearance of Cromer Hall.

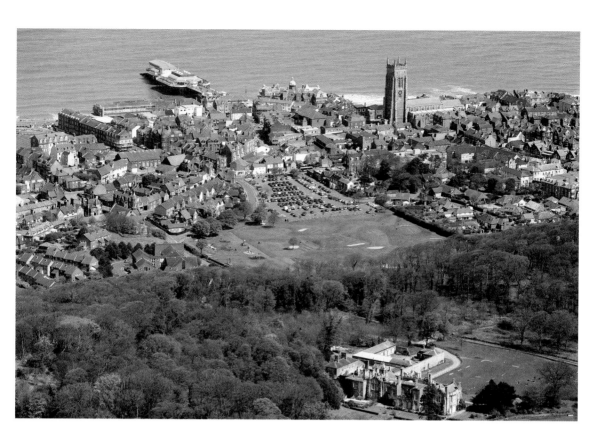

CROMER and the HALL

Although Cromer is now on the coast before erosion took its toll the village of Shipden stood half a mile from the current shoreline and was included in lands owned by the Felbrigg estate, of which Cromer Hall was once part. The location of Shipden church is known to local fishermen.

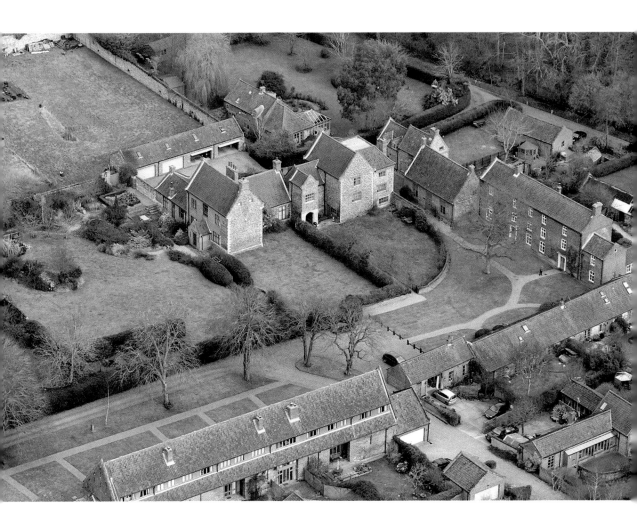

CROSTWIGHT HALL

What remains of the old hall is centre picture surrounded by conversions changing this into a comprehensive but attractive site. The brewhouse and large barn were included in the conversions. The 16th century main house, with its double height porch, was discovered to contain recycled mediaeval brick and flint. The original hall was E shaped with wings added later.

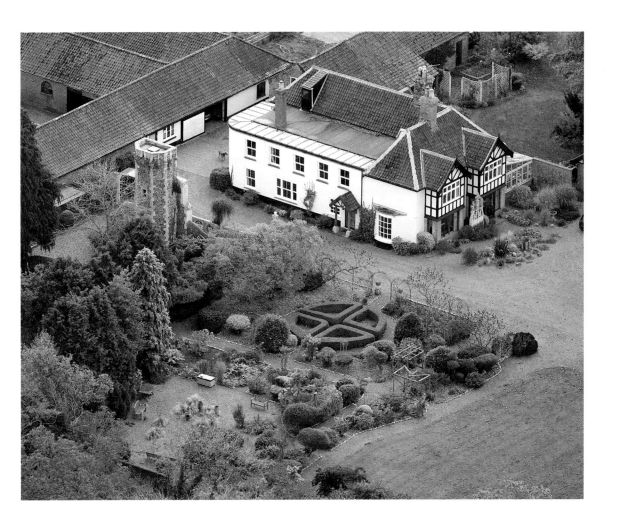

DILHAM HALL

The tower in the garden is the remains of Dilham Castle, actually a 15th century fortified manor house hence its other more accurate title, Dilham Hall. The farmhouse is considerably more recent.

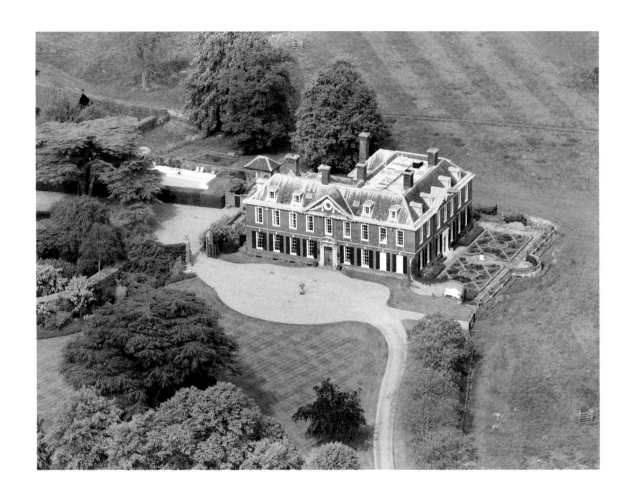

DITCHINGHAM HALL

The original Hall dates from around 1720 with a 20th century modern wing fitting in perfectly. The gardens, which include a large lake ,were landscaped by Capability Brown. Some 20 or so years ago the lake was dredged by means of two steam engines placed either side of the lake hauling buckets of mud across to both banks. It was a scene which wouldn't have been out of place a hundred years earlier.

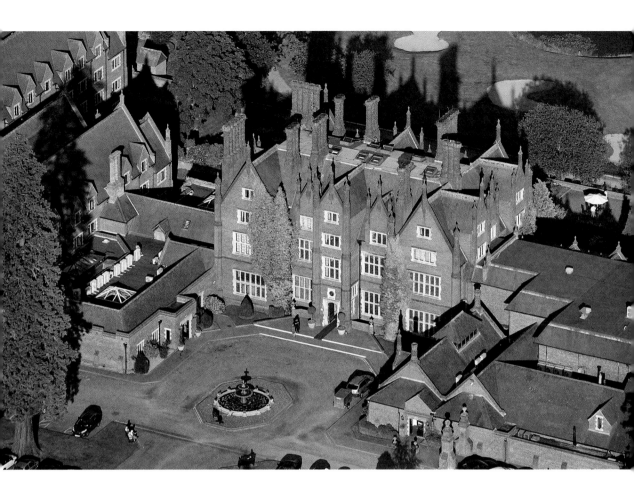

DUNSTON HALL

Built in the Elizabethan style this four storeyed hall is actually late Victorian or early Edwardian. Its architect is believed to have been E.T. Boardman (of How Hill). It's now an hotel and functions venue with adjoining golf course.

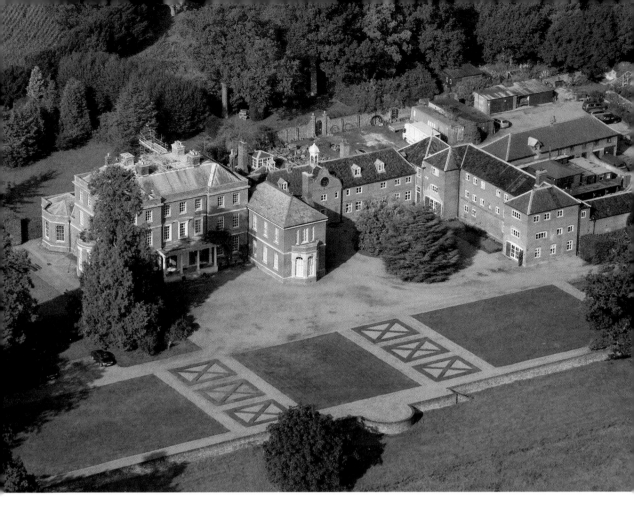

EARSHAM HALL

Begun in the 17th century, with additions in the following two centuries including a room by Sir John Soane (1785), it's believed that some early renovations were funded by profits from the slave trade. The house has undergone various fortunes but for many years has been a pine furniture showroom, the furniture being displayed over many rooms. More recently other rooms have been restored to their original splendour and are used as events venues.

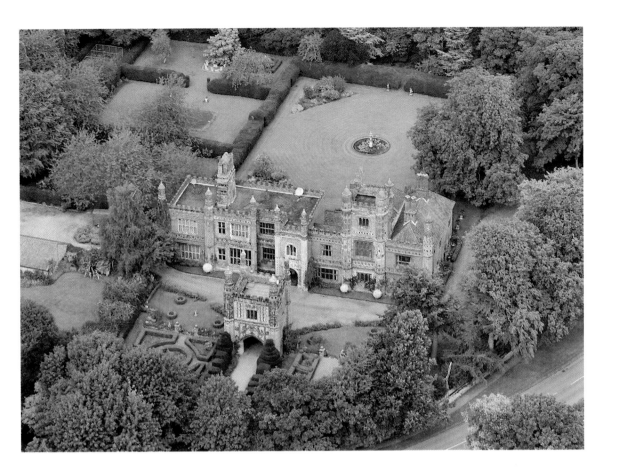

EAST BARSHAM MANOR

Suddenly one comes upon the Tudor gatehouse on the Wells to Fakenham road. The whole manor is a visual feast in moulded rich red brick. Built around 1520, Henry VIII stayed there whilst on a barefoot pilgrimage to the Walsingham Shrine. The original owner had made his money sheep farming in a time of great prosperity for this particular branch of agriculture in East Anglia (hence the magnificent 'wool' churches in Norfolk, for example Walpole St Peter, Salle, Cawston and Worstead and in Suffolk Long Melford, Lavenham, Blythburgh).

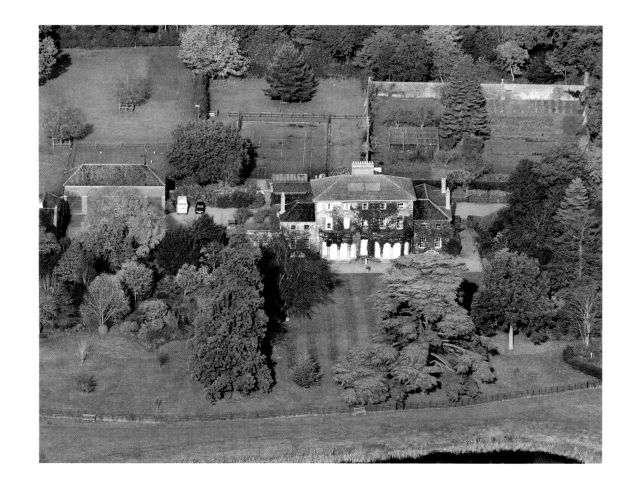

ELLINGHAM HALL

Ellingham is situated only just within the border of Norfolk. The boundary, the River Waveney, is less than a mile away. This ten bedroomed grey brick house was surrounded by common land until 1806 when Parliamentary permission was given to enclose. The hall has remained in the Smith family's ownership for at least four generations.

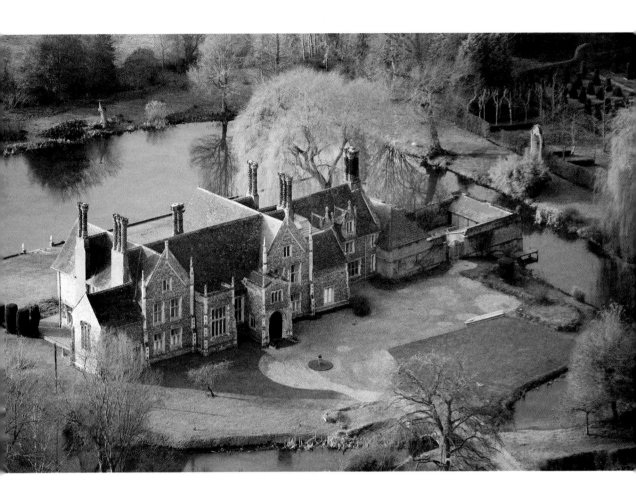

ELSING HALL

Built largely of stone and knapped flint this 'perfect example of a moated manor house' (Wilhemine Harrod - Norfolk born buildings conservationist and historian) was built around 1460. Restored by the Victorians and again after the Second World War, the hall retains its mediaeval hall and chapel.

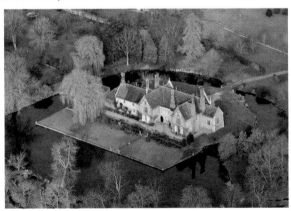

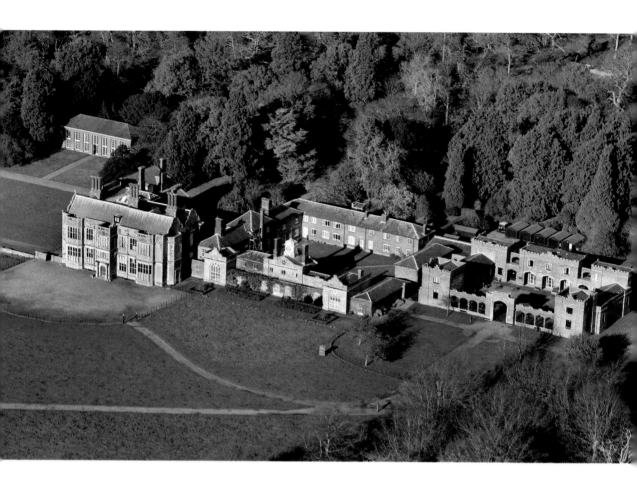

FELBRIGG HALL

Felbrigg is a cosily domestic property of 1620, belonging since 1969 to the National Trust. It passed from the Wyndham/Windham family to the Ketton, later Ketton–Cremers. The estate is mentioned in the Paston Letters. The Felbriggs sold to the Windhams and the stable block, right of picture, was built by Donthorn in 1825, the architect of Cromer Hall.

Opposite, top. The church was absorbed into the estate (see also Raveningham), as was common practice but it remains open to everyone.

Opposite, bottom. the orangery is left of picture and the stable block on the right. This block has special significance because 'Mad Windham' (William Frederick Windham) was highly eccentric and one of his pastimes was driving (in an erratic fashion) the express horse driven coach from Cromer to Norwich. He died aged 26 in 1866.

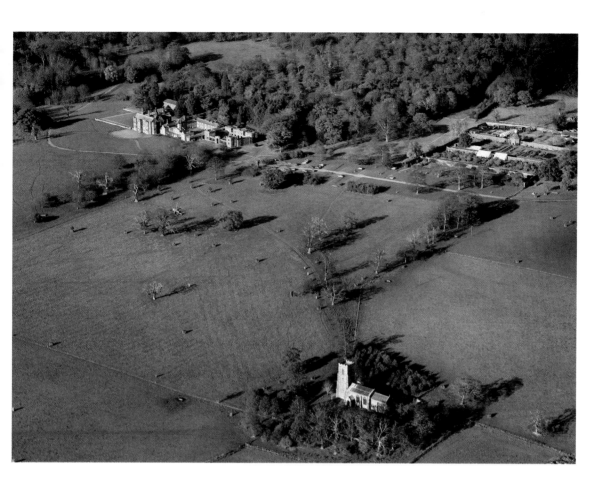

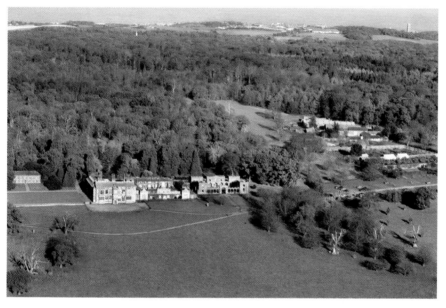

41

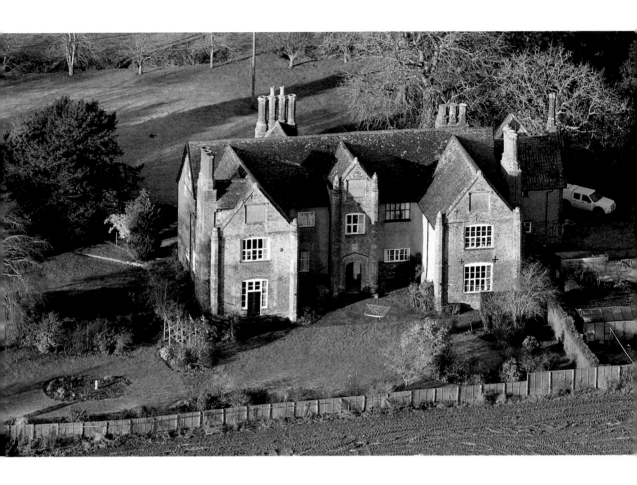

FLORDON HALL

This Tudor farmhouse shares many architectural characteristics with its near but larger neighbour, Rainthorpe Hall at Tasburgh.

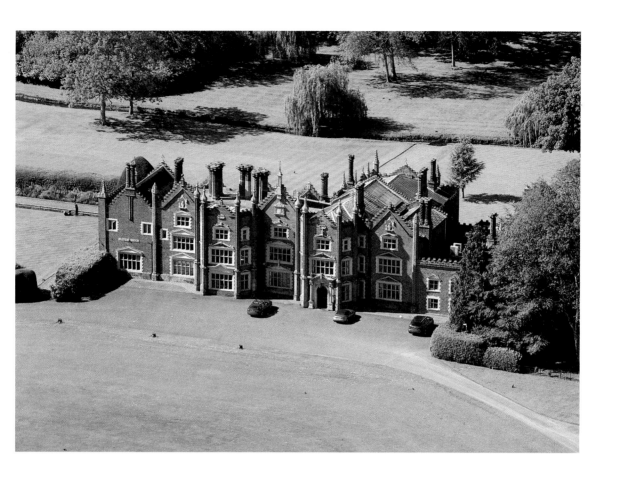

GREAT WITCHINGHAM HALL

Pevsner calls the Hall 'a spectacular piece of Victorian – Elizabethan' but there is also some Tudor brickwork at the rear so parts of the Hall are older than they appear. The tall chimneys are spectacular. In recent years the hall's best known owner has been poultry king 's 'bootiful', the late Bernard Matthews.

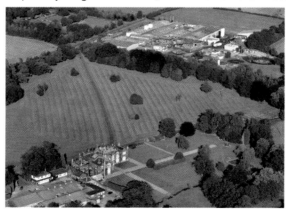

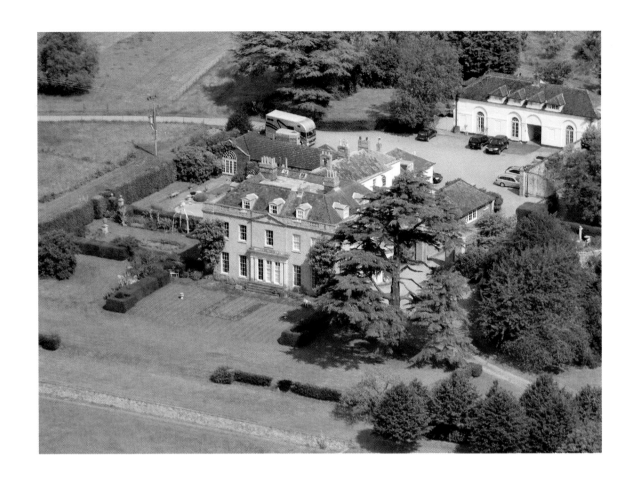

GELDESTON HALL

Of Geldeston Hall, built in 1777, Wilhemine Harrod (compiler of 'The Norfolk Guide') writes 'The village is pretty and the Hall is a nice late Georgian house'

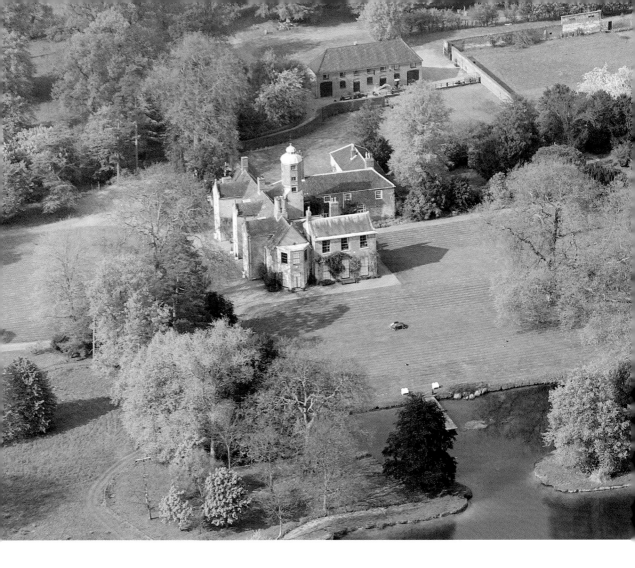

GILLINGHAM HALL

The core of the house is red brick Jacobean but was plastered over in the 18th century when the interior was remodelled. The stair turret stands much higher than the house and although its square at the base it becomes octagonal further up – rather like some church towers.

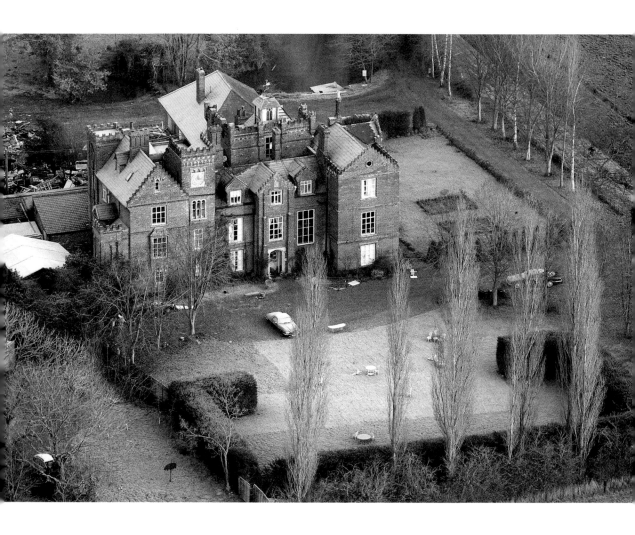

GISSING HALL

A rather forbidding looking house built in the 19th century to resemble an Elizabethan hall. It incorporates a late 17th century rectory.

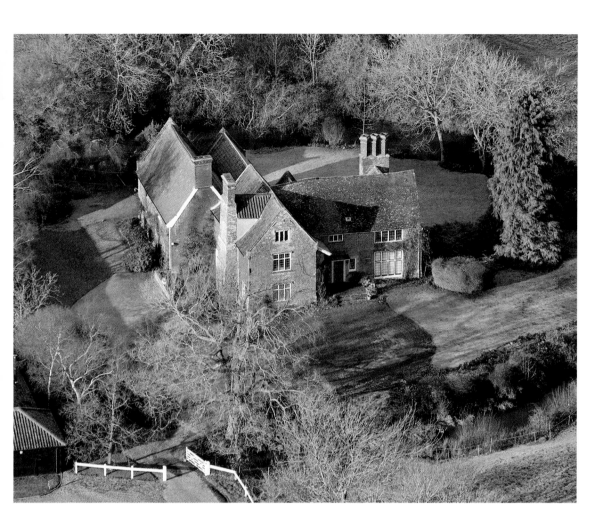

GONVILLE HALL

The original, possibly larger, house was built in the 16th century. It now incorporates careful developments made by its architect owner in 1966.

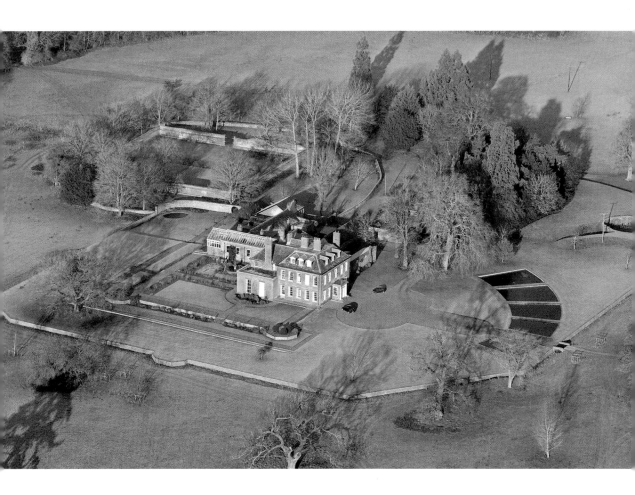

GREAT HOCKHAM HALL

This Queen Anne house, built in 1702 by Philip Ryley, is in the heart of
Breckland. The five modern trapezoid shapes are fed with rainwater run off
from the roof of the house.

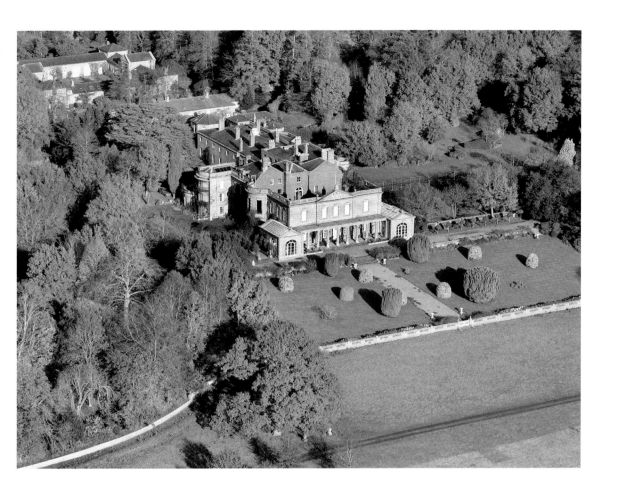

GUNTON HALL

The original architect was Matthew Brettingham, (1742) who had a hand in building Holkham but this hall's real saviour is Kit Martin who rescues elegant houses worth rescuing (this one after a fire) and with his architectural skills converts them into imaginative modern dwellings.

One example of Kit Martin's work is the early Victorian observatory tower, now a house.

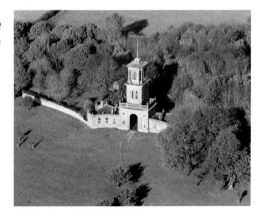

HAINFORD HALL

The late 18th century hall has definitely seen better days but some guide books are so sniffy they deny its existence altogether. Structurally the building is unsound in parts and a fire some years ago has caused further deterioration. Even the enemy aircraft in the Second World War singled it out and bombed the building, mistaking it for Stratton Strawless Hall close by where the RAF had their Opertions Room for RAF Coltishall.

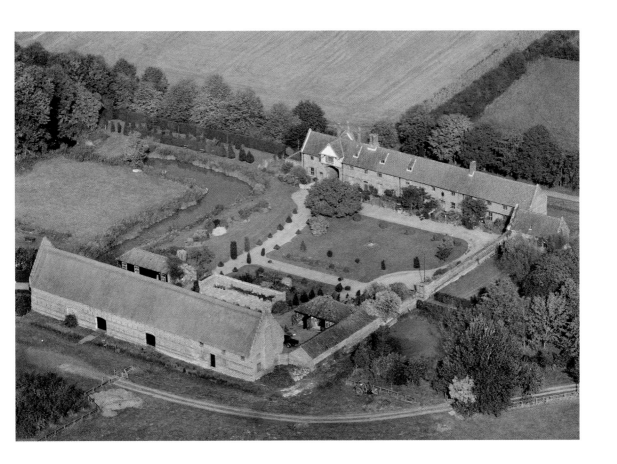

HALES HALL (formerly Hales Court)

Built by Sir James Hobart, Attorney General to Henry VII, the moated house is the second to be built on this site. The barn is huge and is claimed to be the longest in the country; it's now used as a venue for large gatherings. The property is approached on a track over a 66 acre common.

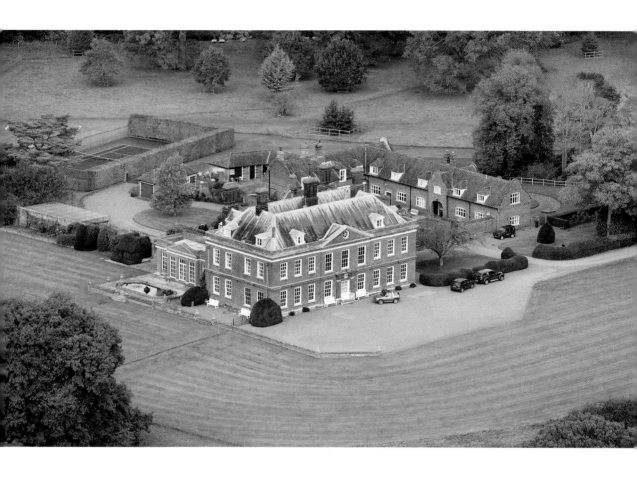

HANWORTH HALL

A fine house of the early 18th century with extensive parkland to match.

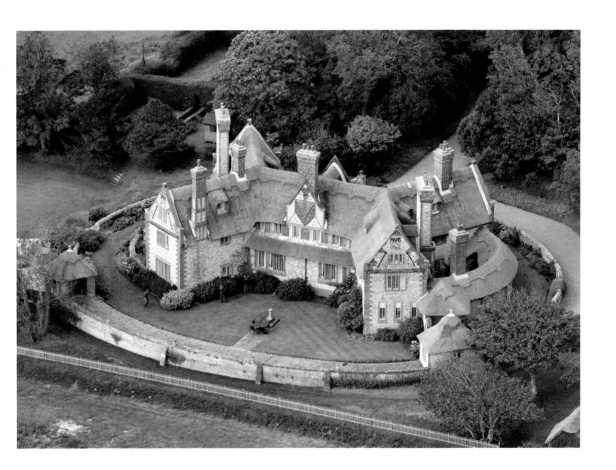

HAPPISBURGH MANOR

Built in 1900 by Detmar Blow (a disciple of Edward Prior and Edwin Lutyens), who used the 'butterfly' or X shape, the thinking being that a broken and non–rectangular plan would make a house blend more closely with its site. In the spirit of the Arts and Crafts tradition local materials were used, reed for the thatch and flint replacing many bricks. Tall chimneys and wide chimney breasts were other Arts and Crafts devices harking back to the Middle Ages.

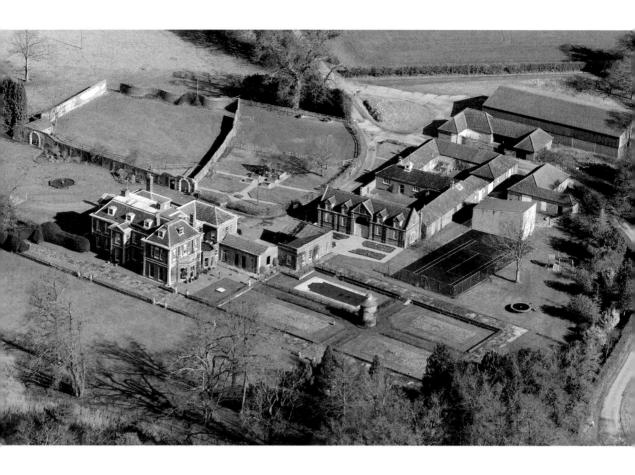

HARDINGHAM HALL

An early 18th century house with 1830 additions. An older hall stands near the church.

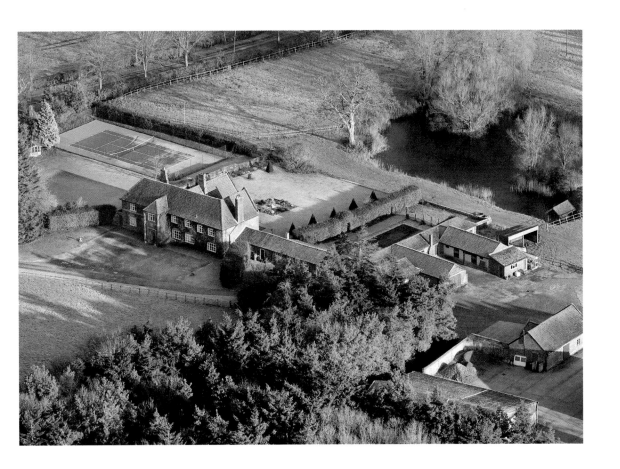

HARDINGHAM OLD HALL

The Old Hall has its origins in the Elizabethan or Jacobean periods. It's close to the church whilst the remainder of this scattered village, including Hardingham Hall, is a mile or so away. It's thought that some of the Old Hall's original plasterwork and elaborate panelling migrated to the newer hall.

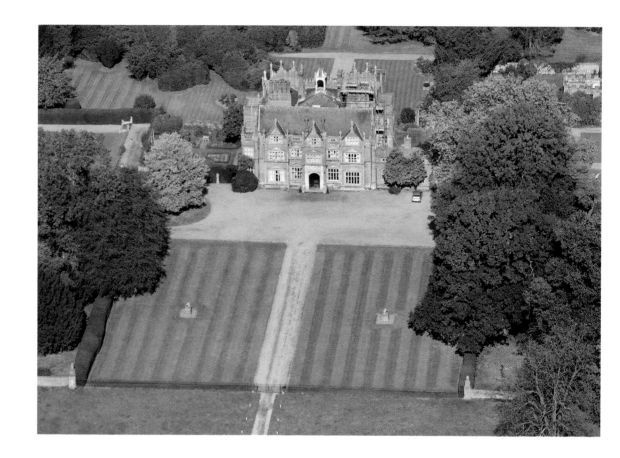

HEYDON HALL

An Elizabethan house (built 1581-4) for Sir Henry Dynne. The Hall has been owned by a succession of Norfolk families and has suffered several changes including demolition of the Victorian wings. Fortunately William Bulwer-Long in the 1970s ignored the then current advice to knock down the whole to avoid horrendous maintenance so we are able to enjoy the delightful entire village today.

Opposite: The long line of trees is all that remains of an elegant drive up to the Hall.

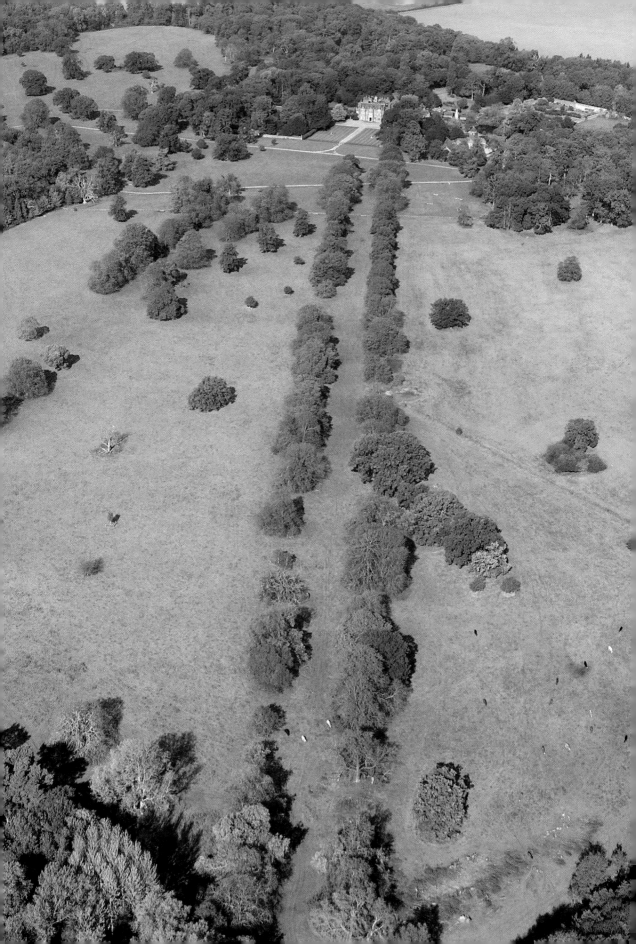

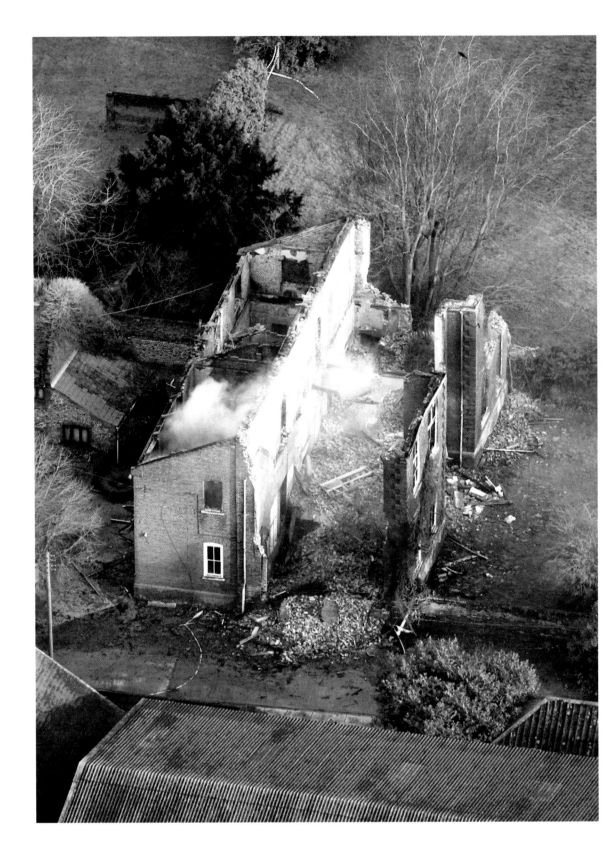

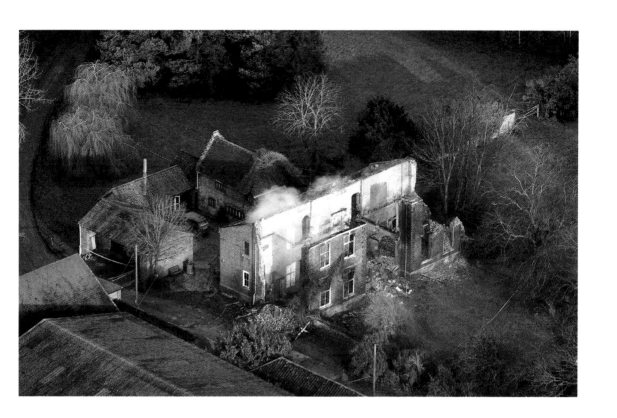

HICKLING HALL

The Grade II listed house was built around 1700. On 26th December, 2014, a fire, thought to have started in a chimney, destroyed a major part of the house. The Calthorpes, who gave their name to the nearby small broad, lived here.

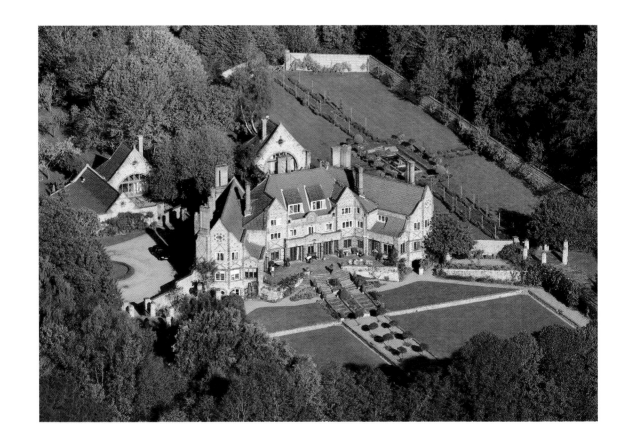

HIGH KELLING, Voewood

There's a certain amount of confusion about the name of this interesting house. It was built 1903–5 at Kelling by Arts and Crafts architect E S Prior. According to Pevsner, initially it was called Kelling Place, subsequently altered to Home Place. Recently it has changed its name again to Voewood. The use of local materials, especially flint, is a hallmark of many Arts and Crafts houses.

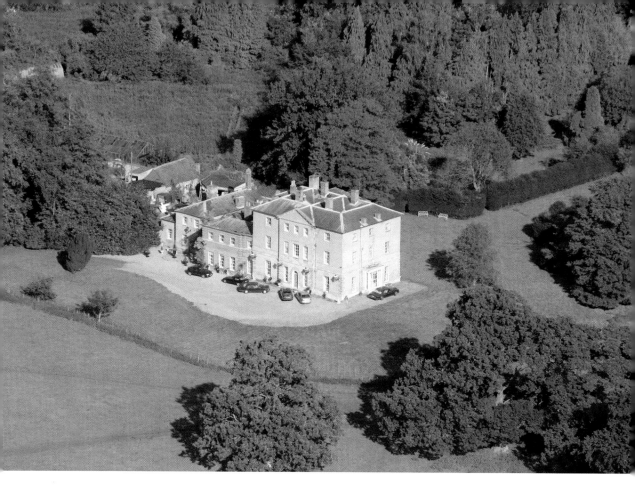

HILBOROUGH HALL

In the 17th and 18th centuries it was considered a bit of a status symbol to build a grand house in white brick rather than in the more easily obtainable, locally made, red brick. It was built for Ralph Caldwell, steward to Thomas Coke of Holkham.

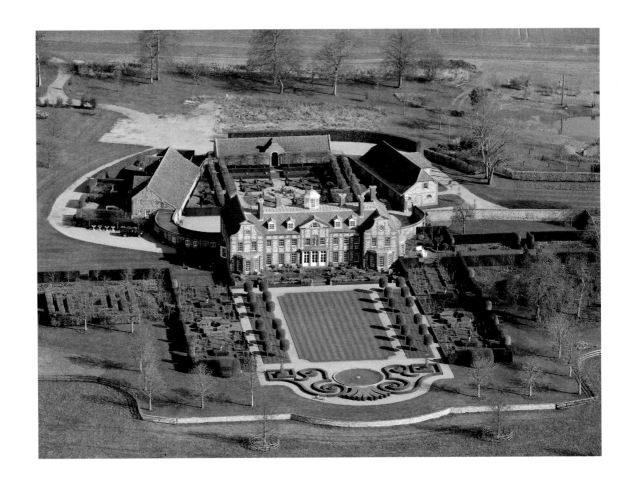

HILBOROUGH HOUSE

This house appears to have stood for at least a century but actually it's quite modern and has a strong Dutch influence both in the style of the house and in the formal gardens.

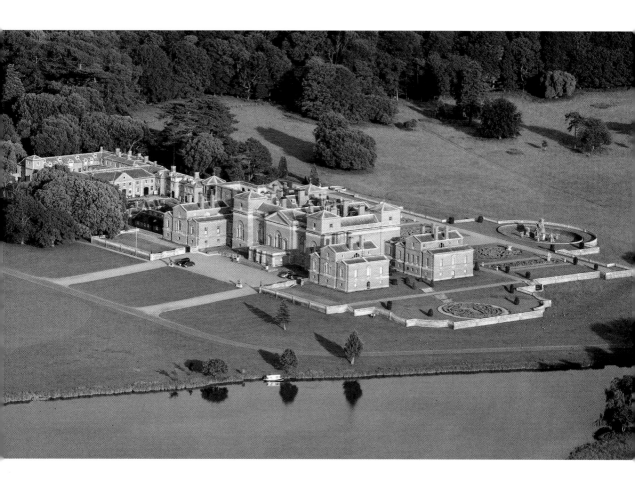

HOLKHAM HALL

One of the great Norfolk Houses, construction was around 1734 for the great uncle of the agricultural pioneer also named Thomas Coke (pronounced 'cook'). The first Thomas Coke became the first Earl of Leicester. It was built by William Kent with input by Norwich's Matthew Brettingham (see also Gunton Hall and Hanworth Hall). It was speculated that Holkham was built of white brick rather than the originally intended Bath stone because the first Thomas Coke had lost a great deal of money speculating in the financially disastrous events which led to the South Sea Bubble. There is a further picture on the overleaf.

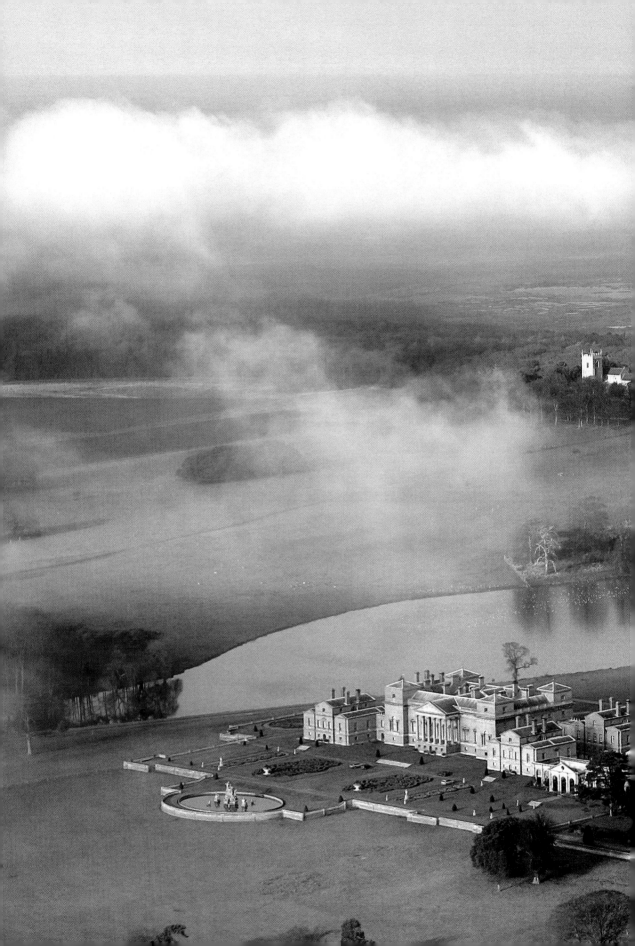

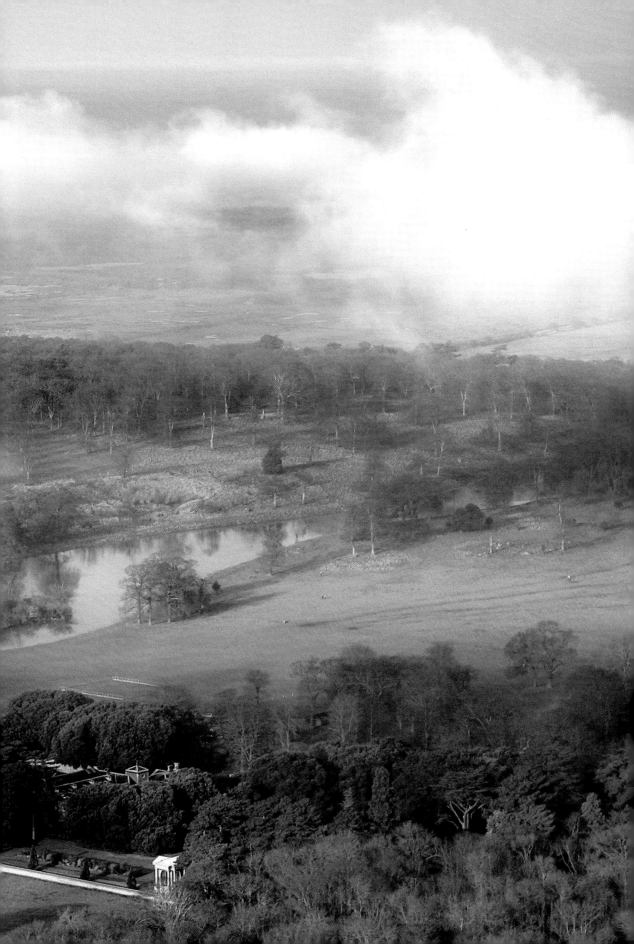

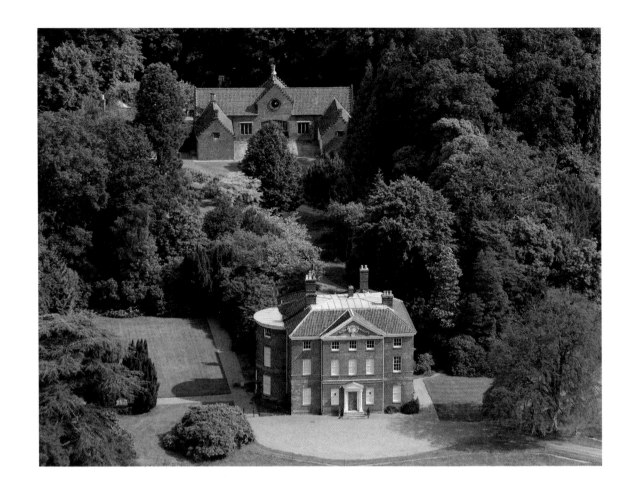

HONING HALL

Honing Hall was built in 1748 by a local family with landscaping by Humphry Repton. There is a coat of arms in the pediment above the doorway but no suggestion of to whom it belongs. In 1784 the house was sold to another Norfolk man, Thomas Cubitt, in whose family the house remains. To give some idea of the scale and status of the house, bookseller and historian David Clarke suggests that at the time of building it would have cost in the region of £1,000 whilst contemporary Holkham cost £92,000.

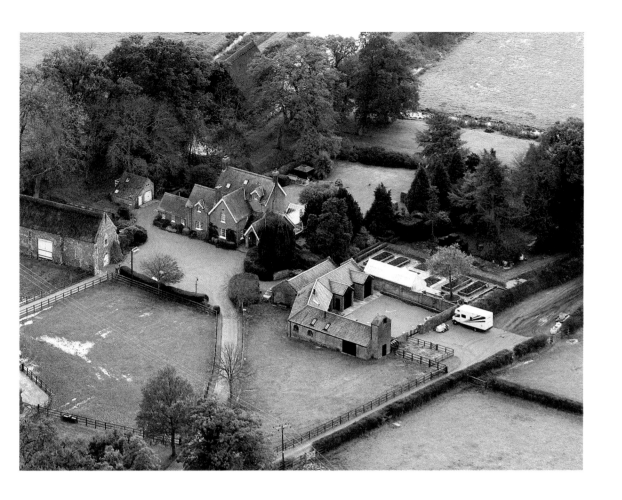

HORNING HALL

This hall would appear to be Victorian but the thatched flint barn opposite the house is much older. It was the chapel of the St James' Infirmary where monks from St Benets Abbey walked along a causeway by the River Bure until they reached the infirmary.

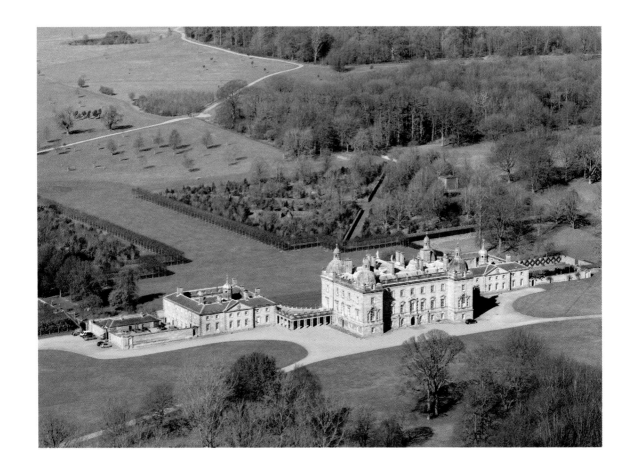

HOUGHTON HALL

Robert Walpole, England's first Prime Minister, built this grand Yorkshire stone residence in 1721, several years before Coke of Norfolk's Holkham was begun. Houghton was believed to have cost £200,000. The house was designed by Colen Campbell, the builder was Thomas Ripley who subsequently designed Wolterton for Robert Walpole's brother Horatio. The four turrets were the idea of Robert Walpole himself. The house later was offered to Edward VII but he chose Sandringham instead. Pictures were sold to pay off Robert Walpole's debts and they were acquired by Catherine the Great of Russia.

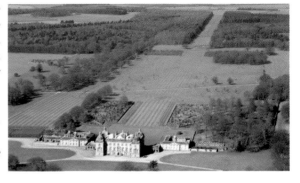

The estate contains St Martin's church where Horace Walpole was buried; this second photo some of the parkland, where deer still roam.

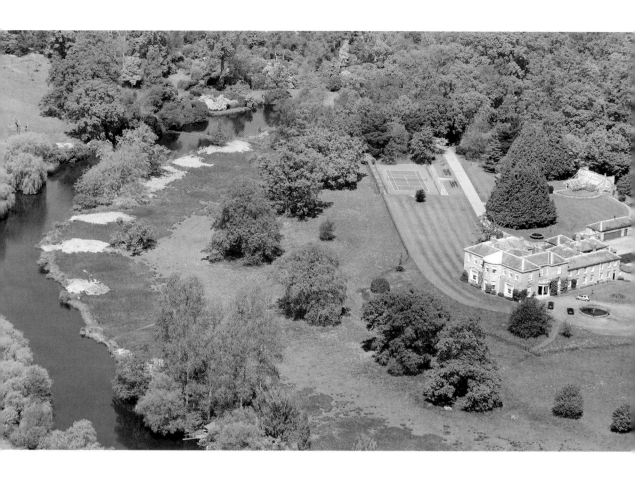

HOVETON HALL

Built of grey brick some time between 1780 and 1825 the central bow window is a feature of the house. The elegant grounds and house have diversified as a wedding and entertainment venue and sporting events are also held here.

According to the Ordnance Survey map the stretch of water is not part of the river as might be supposed but Is a broad.

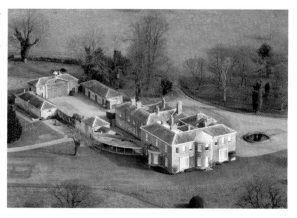

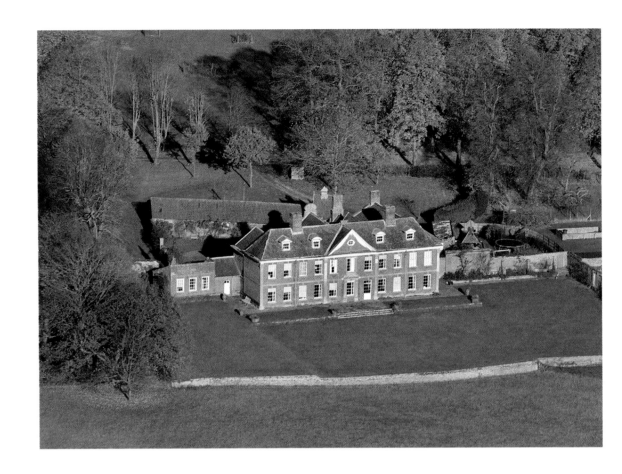

HOVETON HOUSE

Built towards the end of the 17th century, the house has remained in the care of the same family since construction. Pevsner says of the fancy pediment above the central doorway 'it has a lot of not very disciplined vegetable carving'. The gardens were laid out in the early 19th century by Humphry Repton. Repton, who first set up as landscape designer when he was 37 having had two not very successful careers as a merchant and in politics, went on to design the landscapes of important country houses such as Holkham, the park at Honing Hall and with his son John Adey Repton, the park at Sheringham Hall. He produced over 70 'Red Books' (covered in red leather) containing watercolour illustrations of the work he proposed at individual houses and it's believed that these were instrumental in his success since 'a picture's worth a thousand words' ; a sentiment shared ruefully by the writer of these texts given the huge successes of Mike Page's beautiful photographs.

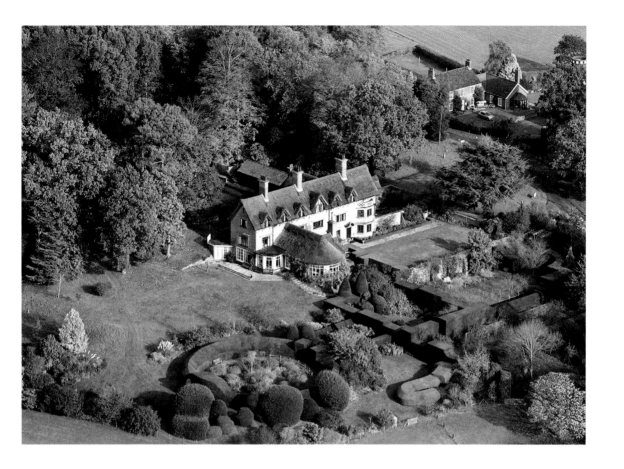

HOW HILL HOUSE

There have been very few Norfolk country estates created within the last hundred and fifty years but How Hill is one of them In 1903 Norwich architect Edward Thomas Boardman discovered this fine site on high ground overlooking the River Ant at Ludham and built there a house for his young family. The house he created owes much to the Arts and Crafts movement which was then at its most popular. The thatched roof, hand crafted fittings, sunny aspect to all the major rooms and a garden greatly influenced by the writings of Gertrude Jeckyll, with her emphasis on colour and herbaceous plants, were all devices employed here. The water garden in the foreground was created almost fifty years ago by the architect's grandson Peter Boardman and reflects the original water garden created by Edward on low lying land to the north of the estate and still in existence.

Overleaf: From the principal rooms the view from the house down to the river and across to the reed beds would have been similar to the one we see today except that the boats would have been working craft under sail rather than motor cruisers.

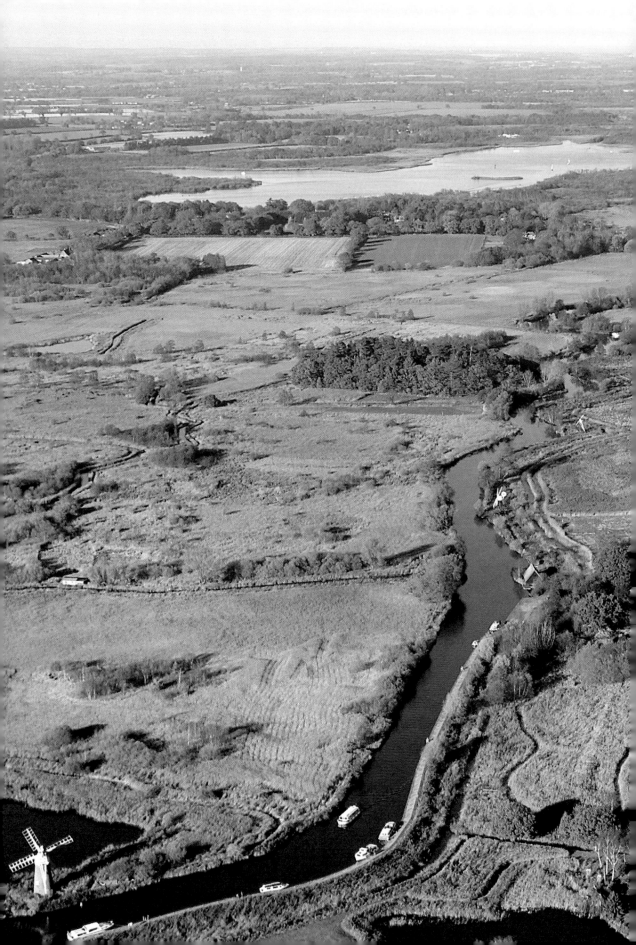

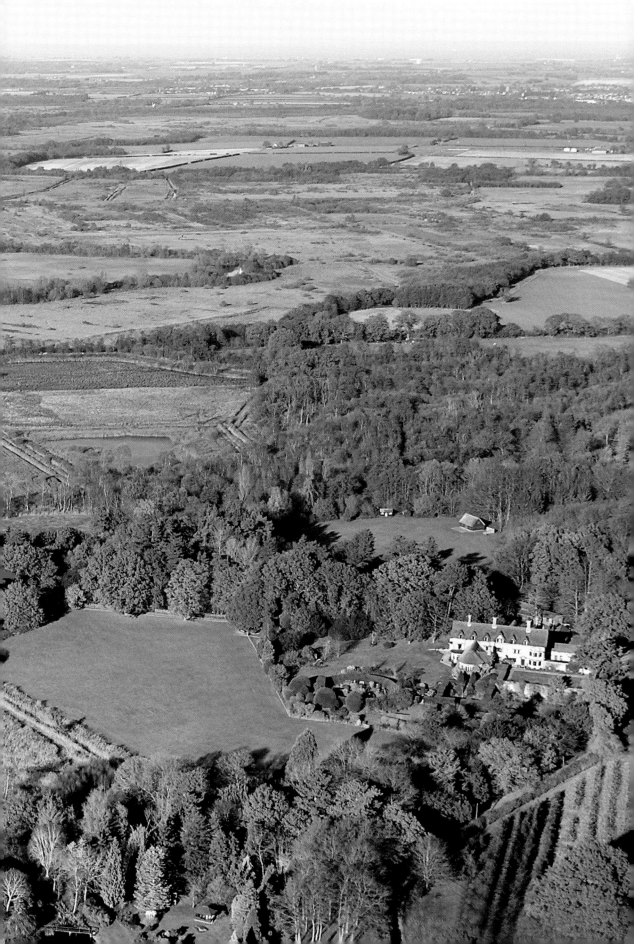

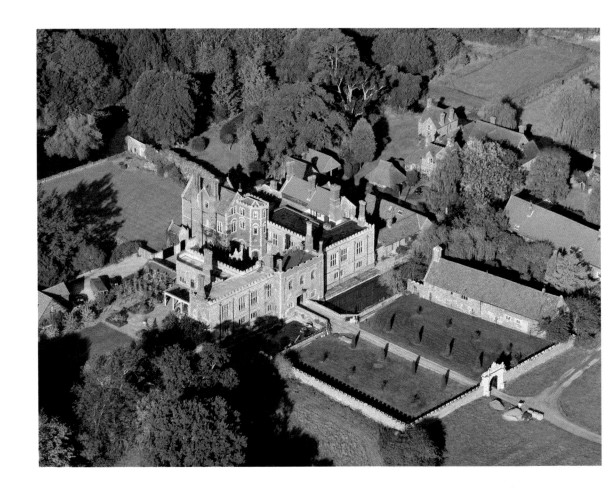

HUNSTANTON HALL

The moated hall was built in the late 15th century by the LeStrange family. The estate was created by Hamon LeStrange around 1310 but very little of an earlier house remains. Remembering that the coastline has eroded in recent centuries the Hall originally stood on an island in marshy ground at the source of the River Hun. The gatehouse was built by Roger LeStrange around 1485. The Tudor range was added by Nicholas LeStrange in 1578 but was destroyed by fire in 1853. Today what is left of the house has become three separate dwellings and no longer has direct LeStrange connections except that in the 18th century the Stylemans inherited the estate and assumed the Le Strange name.

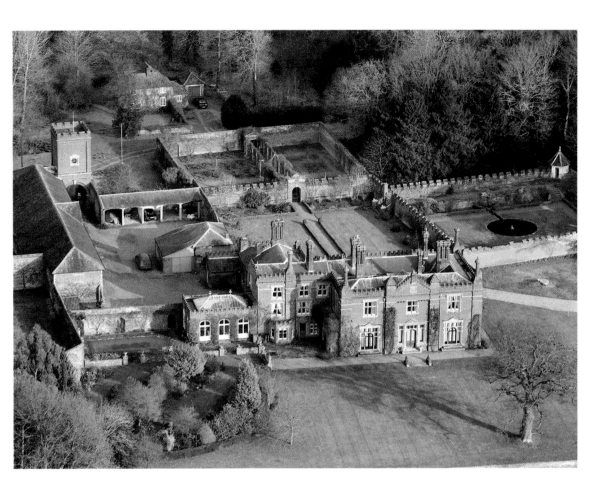

INTWOOD HALL

The red brick Tudor style hall was built 1807 on the site of an earlier house.

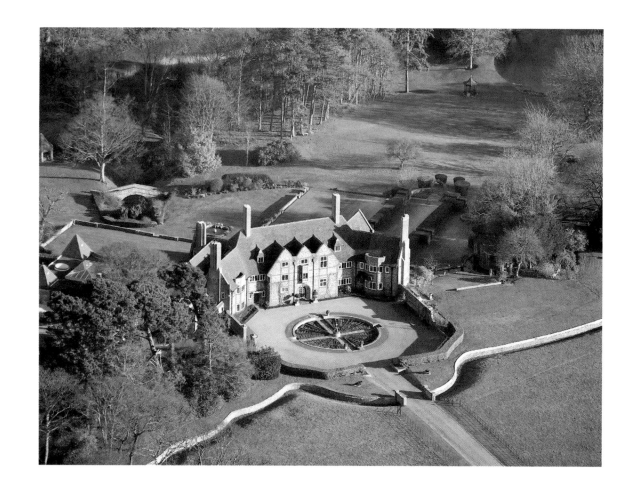

KELLING HALL

Yet another 'Arts and Crafts' house (1905-10) within a small radius of North Norfolk (Happisburgh Manor, Voewood, Overstrand Hall and The Pleasaunce). Between 1900 and the First World War this area contained some very rich people who were willing to 'take risks' with a new style of building. Kelling Hall was built for an oil magnate and assumes the 'butterfly plan', with wings at angles, to catch the sun.

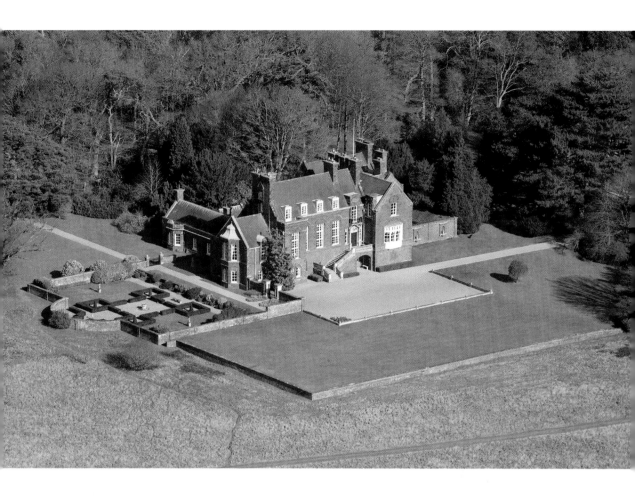

KEN HILL, Snettisham

This is an extraordinary house. Built around 1883. Pevsner says 'The freedom from imitation of anything in particular and yet the character of period allegiance are indeed remarkable'. Constructed as a shooting box by an owner with money made in industry, the house attracted the Prince of Wales when he visited Sandringham.

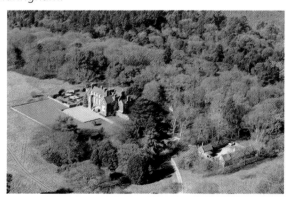

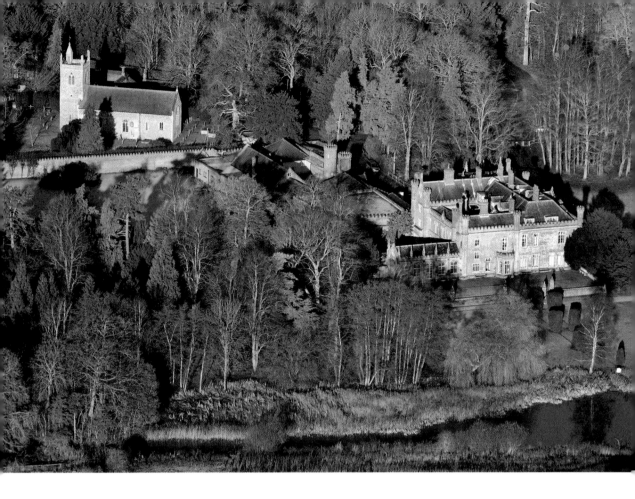

KETTERINGHAM HALL

The original Tudor house was remodelled around 1840. From 1942-45 during the Secnd World War the hall was the headquarters of the 2nd US Air Division of the 8th USAAF in Norfolk; a memorial plaque in the grounds commemorates those who served. But an earlier battle waged over three decades had taken place 1835-68. The protagonists in a village power struggle were the squire Sir John Boileau and the parson, the Reverend William Wayte Andrew. The irony is that they now share the churchyard and one hopes that they're both resting in peace.

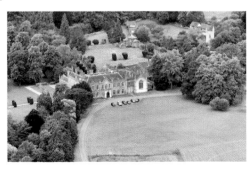

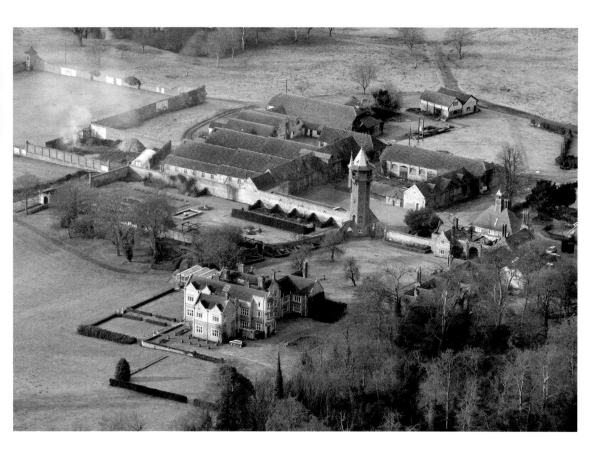

KILVERSTONE HALL

The house dates from around 1620 but was modernised in 1913 and enlarged in 1928, so it has more of a Victorian than an earlier appearance. The eccentric looking water tower (1905) dominates the site. The agreeable outbuildings were designed by the Norwich firm of E.T. Boardman (of How Hill). In recent years it was the centre of a wildlife park and zoo run by the third Baron Fisher of Kilverstone but it closed in the early 1990s.

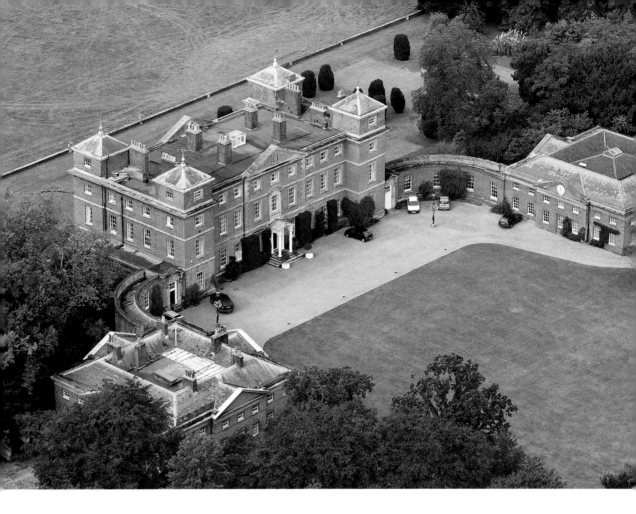

KIMBERLEY HALL

The increase in rents due to agricultural prosperity in the 18th century led to the building of many fine houses on Norfolk estates, quite often as at Kimberley (1712) on the site of earlier houses. The corner towers were copied from Holkham and Houghton. Lancelot 'Capability' Brown was commissioned to landscape the park in 1778. Army occupation during the Second World War caused a great deal of damage but the compensation paid for a remodelling of the entrance front. The Wodehouse family owned the land at Kimberley for around 700 years until 1958 when they left Norfolk.

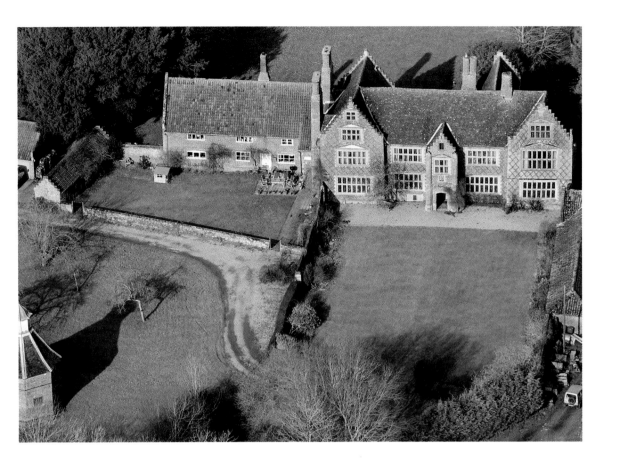

KIRSTEAD HALL

This is a fine Jacobean house, built 1614, with splendid blue diaper brickwork and stepped gables. A dovecote (bottom left of picture) would have provided extra meat from young pigeons (squabs). Apparently once the young birds have flexed their muscles flying then the meat becomes tough and less tasty.

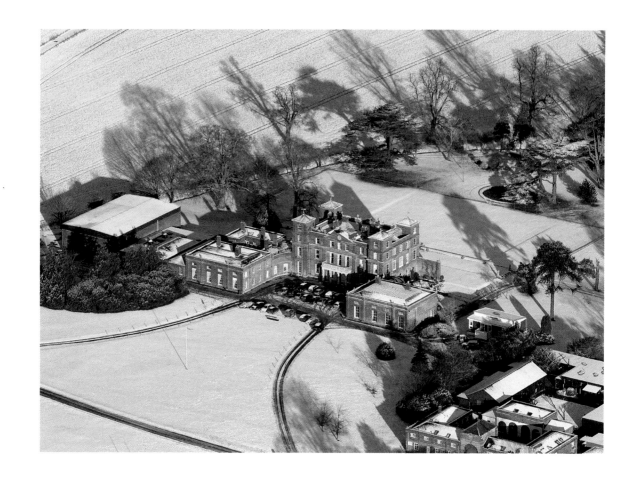

LANGLEY PARK

Now a private school, Langley Park was built 1742–1746 with the towers and wings added by Matthew Brettingham (see also Holkham). It would seem that Brettingham was often brought in as an 'additional' architect. On the main Norwich to Loddon Road there stand two elegant but disused gatehouse lodges to the park. The gatehouses were designed by John Soane (1784).

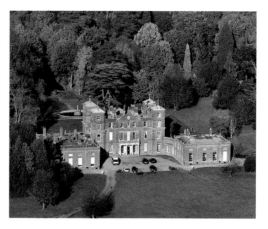

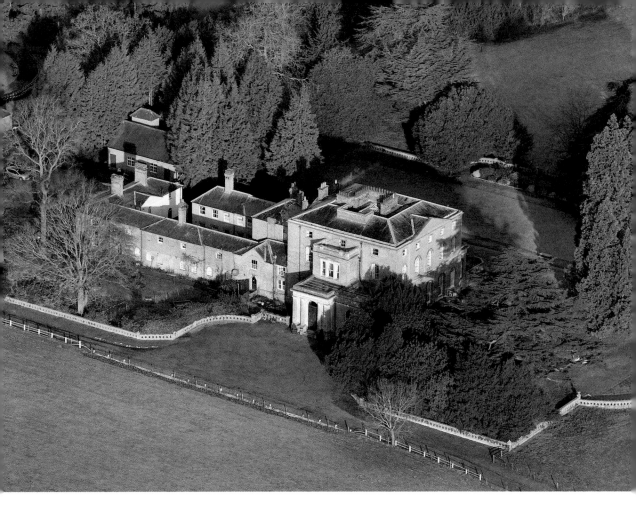

LETTON HALL

John Soane built the Hall in 1783 (he didn't receive his knighthood until 1831). In common with many other country houses of this period Letton Hall was built on the site of a previous dwelling. Letton Hall was Soane's first large country Hall commission. The later additions belong to the 19th century. In 1979 the Hall was sold and now is run as a Christian Holiday and Activity Centre.

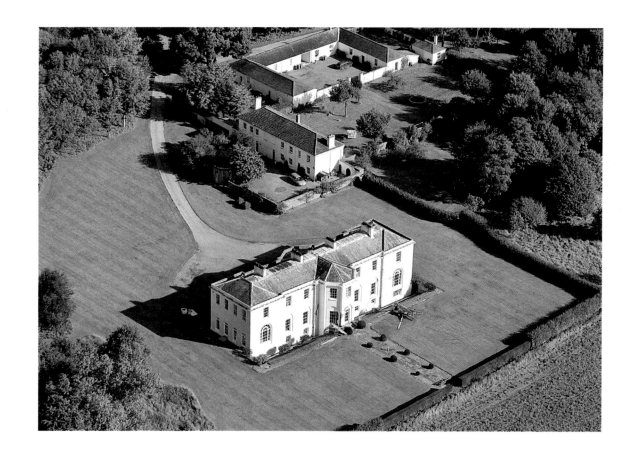

LITTLE CRESSINGHAM, Clermont Lodge

In the church there's a large tablet dated 1806 to Viscount Clermont, William Henry Fortescue, an Irish MP. The then heavily mortgaged house was remodelled in 1812 as a shooting lodge which on the death of Viscount Clermont passed to his nephew the second Earl of Clermont. It was originally of red brick, discovered during restoration in 1973.

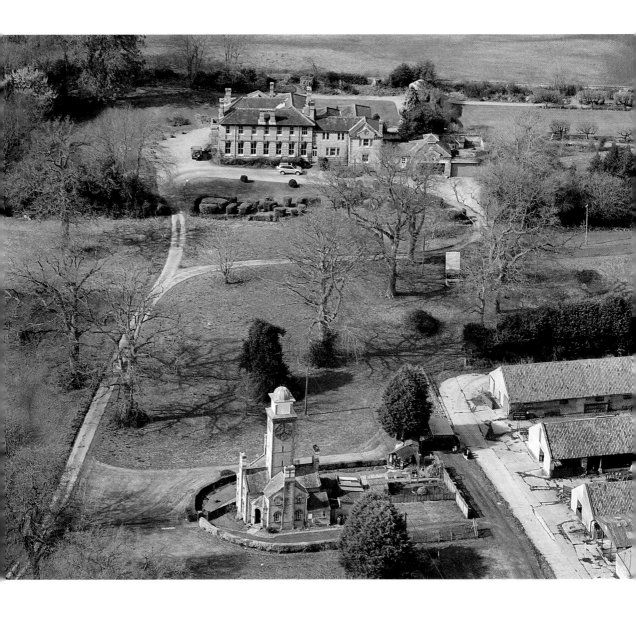

LITTLE ELLINGHAM HALL

The Hall was built in 1855 and looks of its period but the clock tower is extraordinary. Built concurrently, the tower base houses at least one, possibly four, dwellings.

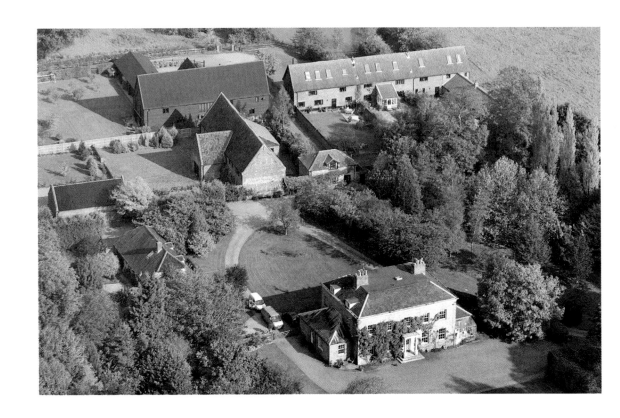

LODDON HALL

The creation of the bypass enabled this small market town to revert to exactly what it had been for centuries. The late Georgian grey brick Loddon Hall is small by country house standards but has very pleasant features from that late 18th century or early 19th century period.

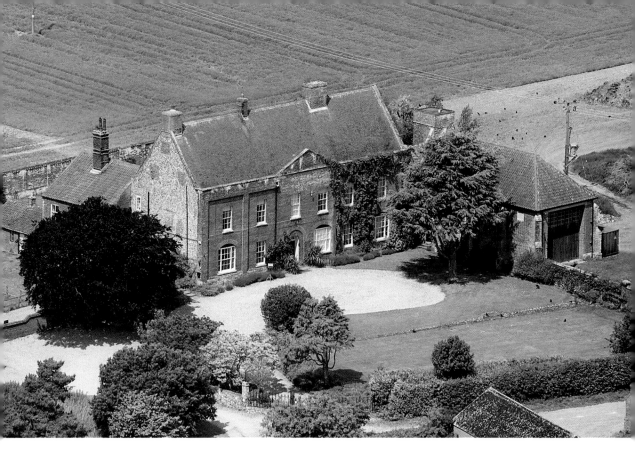

LUDHAM HALL

This elegant Georgian hall is a remodelling of a Jacobean house on the same site. Unusually, to the right of the house is a former chapel, built 1611. The hall was once one of the Bishop of Norwich's country houses and the chapel was built for his use after the dissolution of St Benet's Abbey at the Reformation..

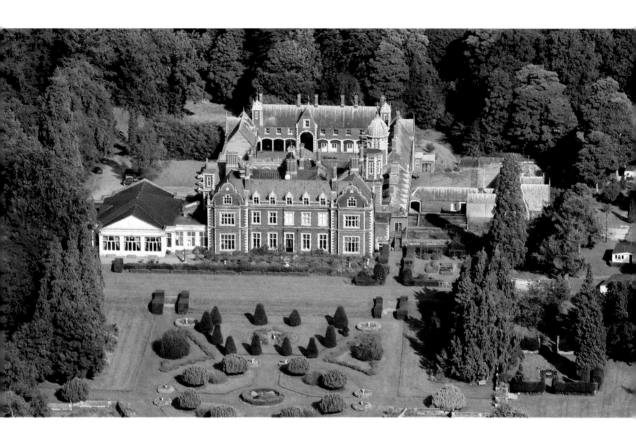

LYNFORD HALL

This is a neo–Jacobean hall built 1856-61, now an hotel. Surrounding the hall is a wonderful arboretum of mature trees which is open to the public. The arboretum was once the parkland for the hall when it was the country seat of James Nelthorpe MP (died 1734) .

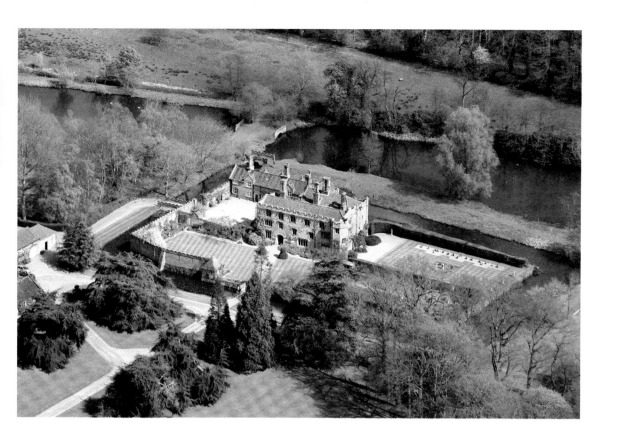

MANNINGTON HALL

By 1460 the owner of the house had been given licence to crenellate, to construct pseudo–defensive ramparts. In 1736 it was sold to Horatio, brother of Robert Walpole – England's first Prime Minister. At the time Horatio was building nearby Wolterton Hall.

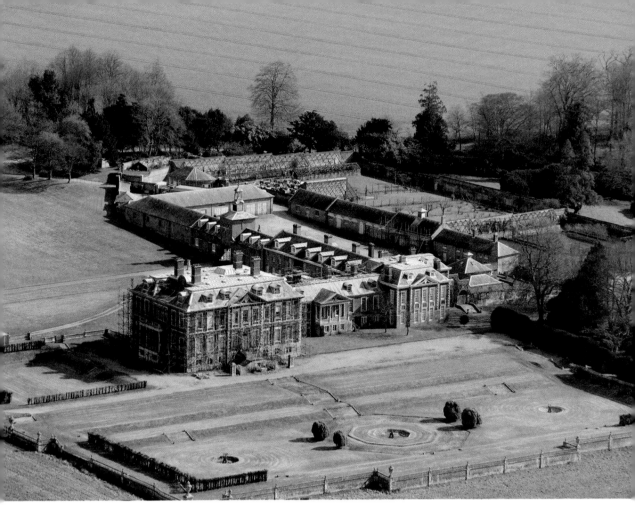

MELTON CONSTABLE HALL

The Hall (the oldest part 1664-70 and built by Sir Jacob Astley) is remembered as the setting for the film 'The Go-Between' (1970). The novel was set in Norfolk although in the book the Hall was never identified. As is the fate of so many large country houses it has suffered various misfortunes but there is hope that it will be converted to provide elegant housing. Its future is uncertain. Pevsner states that it is 'one of the most perfect examples of the so called Christopher Wren house'. A model was made during construction of the house, later it became a 'Dolls' House' and lived in the Hall.

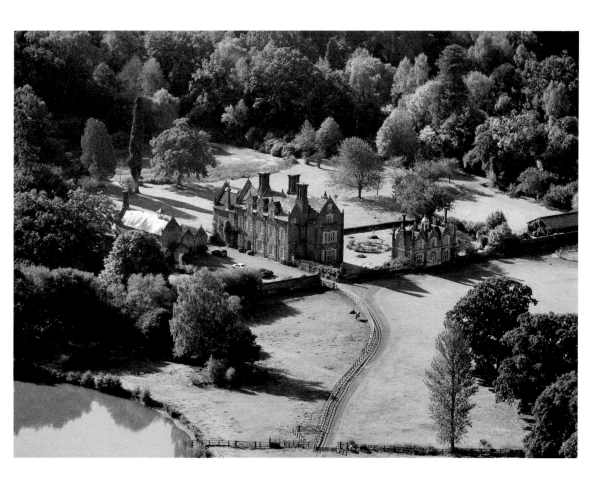

MERTON HALL

Only part of the 19th century building remains. Using as evidence a trunk bearing the initials HR and a king's crown it's speculated that Henry VIII broke his journey here whilst on a pilgrimage to Walsingham

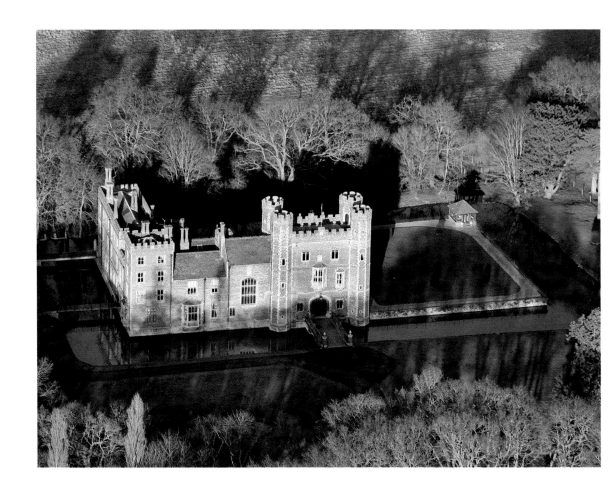

MIDDLETON TOWERS

The gatehouse dates from the 15th century; most of the rest was rebuilt around 1860 and 1900. The gatehouse dates from the same period as Baconsthorpe and Caister castles.

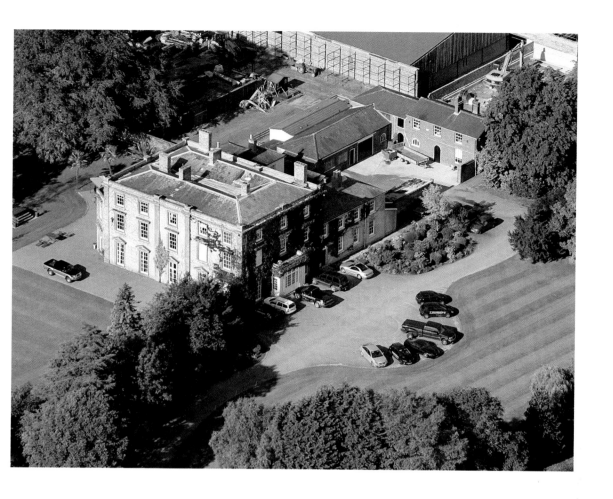

MORLEY HALL

Not to be confused with nearby Morley Old Hall. Morley Hall, adjacent to
Wymondham College, is now the headquarters of a civil engineering firm.

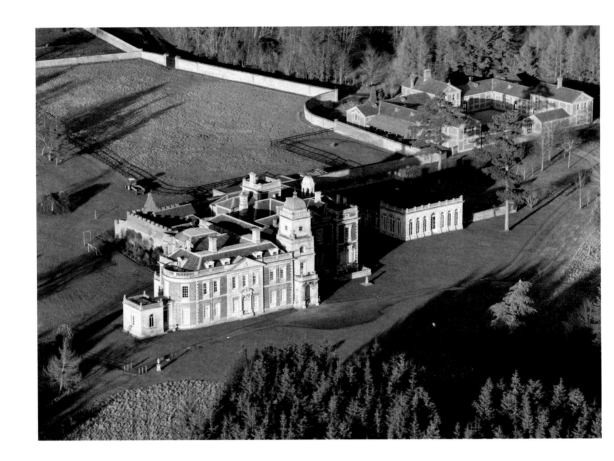

NARFORD HALL

The house was begun around 1700 and has later additions, including the tower (1860). At some point the formal gardens were altered to provide more of a landscape in the style of Capability Brown and had the almost obligatory lake of the period. It is fed from the River Nar, a tributary of the Great Ouse.

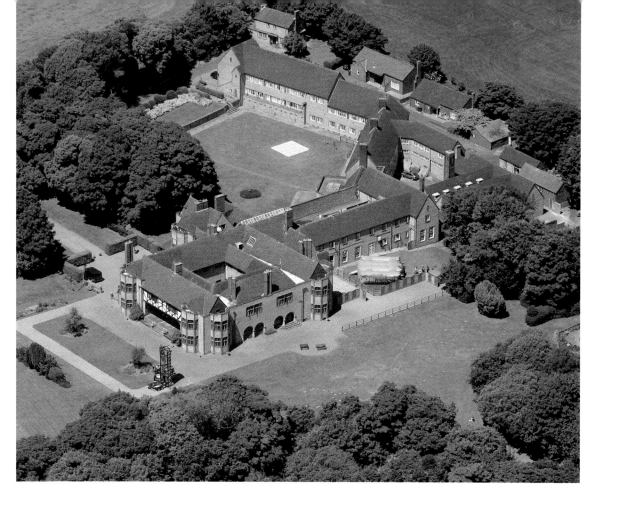

OVERSTRAND HALL

In the prosperous days before the First World War, several rich people built their holiday homes on the Norfolk coast. Overstrand Hall was designed by Edwin Lutyens (1899) for banker Lord Hillingdon. This was an exciting period in English architectural design when the old orders of architecture were turned on their heads by striking designs which harked back to the mediaeval era. With a new wave of architects – Lutyens, Prior,Lethaby, Ashbee, Macintosh and in Norfolk, Boardman and Skipper – came less traditional devices (entrance doors no longer always placed centrally, featured chimney breasts, stucco instead of brick, unconventional ground plans). Once large houses such as these ('The Pleasaunce' also by Lutyens is in Overstrand too) leave the ownership of the original client their use often ceased to be domestic – Overstrand Hall became the Leicester and County Convalescent Home and currently is a field studies centre, The Pleasaunce is a Christian Endeavour Holiday Centre.

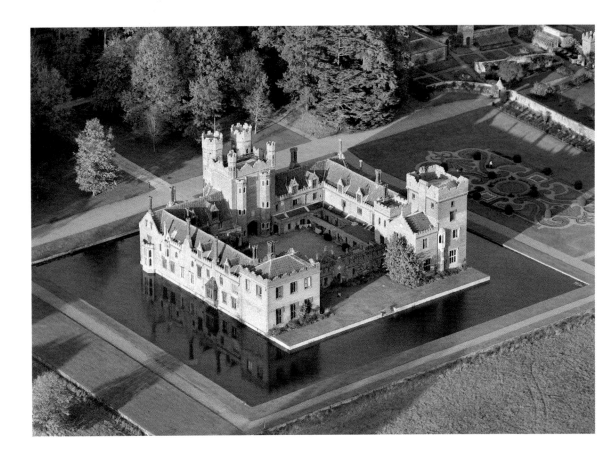

OXBURGH HALL

The moated house was built around 1482 by the Bedingfield family who are still there and who remained staunchly Catholic after the Reformation when Catholic persecution was widespread. The house has a priest's hole where a Catholic priest could hide when he was being hounded during the reign of Protestant Elizabeth I. Around 1835 the tower was added The Hall and grounds are now open to visitors under the auspices of the National Trust

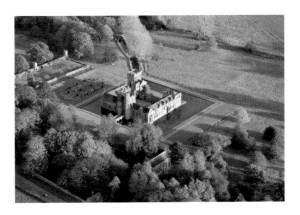

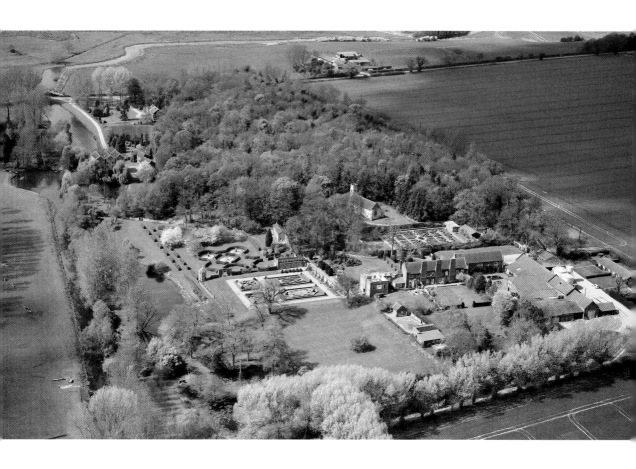

OXNEAD HALL

Oxnead was the principal house of the Paston family after they became more prosperous and moved from Paston Hall. As their fortunes declined – largely attributed to the expensive addition built for the visit of Charles II and his retinue – the house was sold (1730) and most parts demolished. The buildings which stand today comprised the service wing. The River Bure flows past the grounds. Upstream a couple of miles was the original end of navigation at Aylsham.

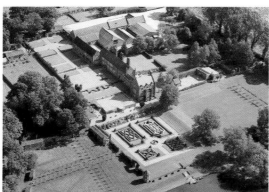

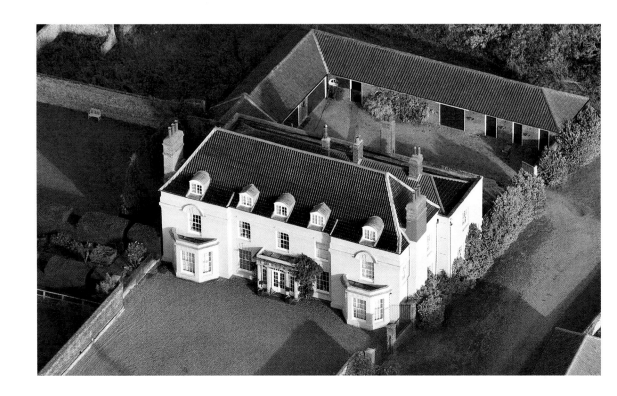

PUDDING NORTON HALL

The 18th century Hall was remodelled or updated at least twice in the following two centuries. That in itself is refreshing when the surrounding area is a 'lost village' and the church reduced to a sparse ruin.

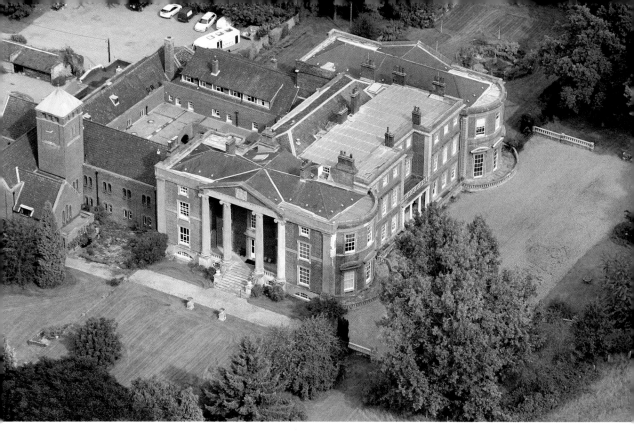

QUIDENHAM HALL

Often confused with the East Anglian Children's Hospice (EACH) which shares the same site, Carmelite nuns live in the former Elizabethan mansion, note the typical inner courtyard. Very little of the older era remains, the Georgian remodelling is more evident.

Below: To the left of picture stands a more recently built church (not to be confused with the parish church with its Anglo Saxon round tower). Art Historian Sister Wendy of TV fame is based here at Quidenham.

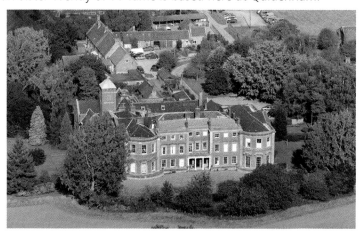

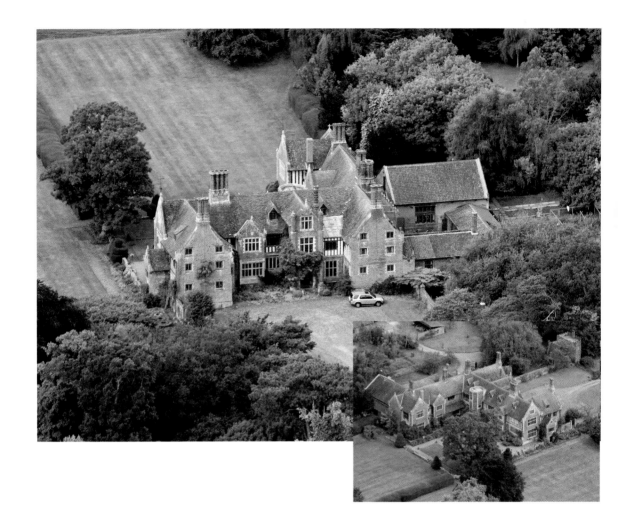

RAINTHORPE HALL

The hall was built in the 1500s. In 1762 it was bought by the Hon Frederick Walpole, MP for North Norfolk, who was related to the Robsarts and who incorporated their coat of arms into his own. An unusual feature of the hall is that although it is brick built the first floor is half timbered. The wings are a later addition as is evidenced by the omission of the blue brick diapering of the original house.

 The polygonal circular stair turret sits somewhat uncomfortably, seemingly 'tacked on' a wing. The property runs down to the River Tas where there were stewponds to keep the house supplied with fish. This was a common arrangement in Tudor times; among the best still evident among the ruins are the stewponds of St Benet's Abbey.

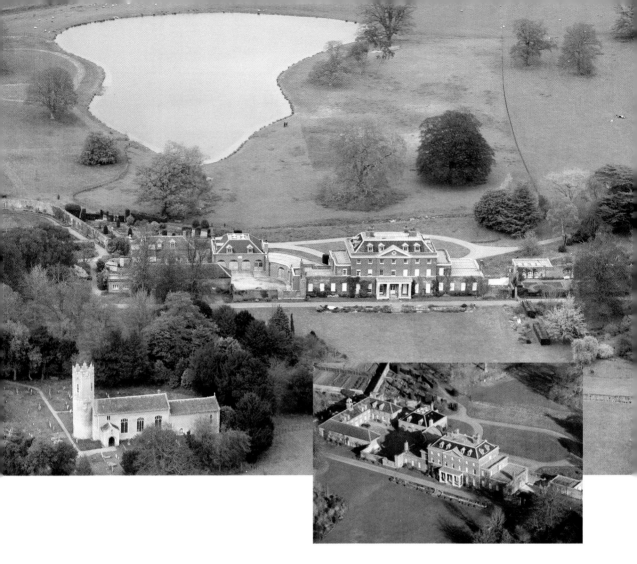

RAVENINGHAM HALL

The red brick Georgian house with 19th and early 20th century additions stands within its own parkland which incorporates the church also, an arrangement common when houses of this period were built (see Felbrigg and Blickling for example).

The lake was created in 2000 AD as a Millennium Project.

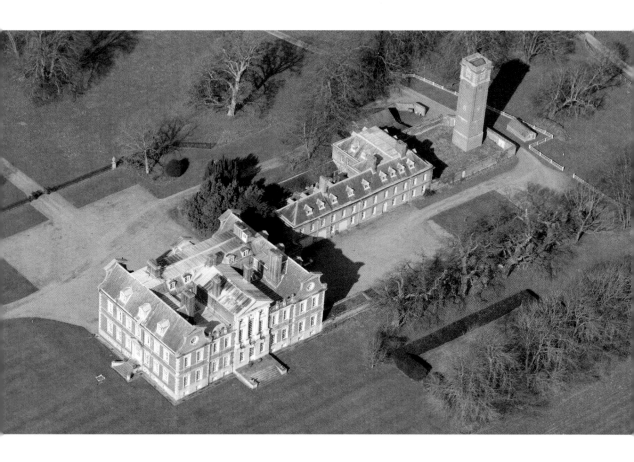

RAYNHAM HALL

Raynham (East Raynham), home of the Townshends, was begun 1622. The second Viscount ('Turnip Townshend') was the inventor of the Norfolk four course agricultural rotation system advocating successive crops of wheat, turnips, barley and clover.

He was Secretary of State in Robert Walpole's government. The house is built from red brick and stone, the Dutch gables at either end of the wings were a new fashion at the time. There is a possibility that Inigo Jones was the architect, William Kent designed much of the interior as he did at Houghton.

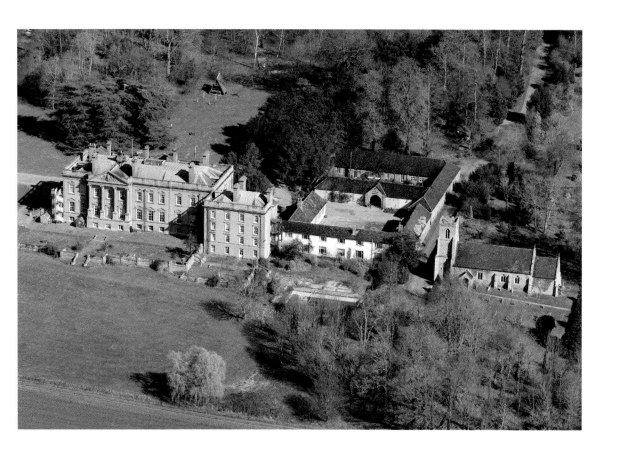

RIDDLESWORTH HALL

The style of this house makes it appear to be older than it is. Built 1900 by a Norwich architect it is a copy of the burned down hall it replaced. It has gained fame as the Boarding School where Lady Diana Spencer was educated.

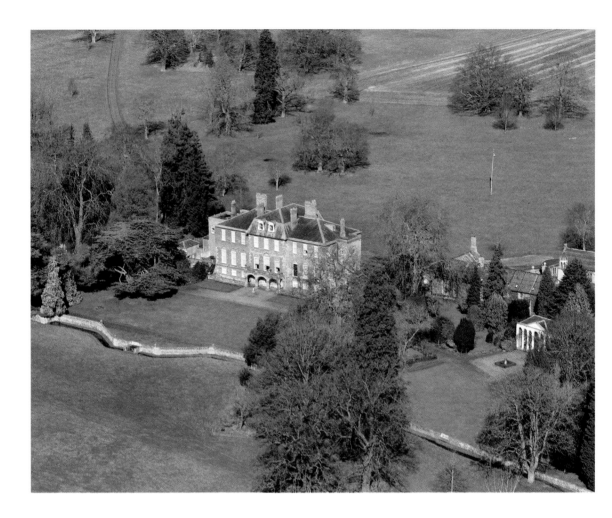

RYSTON HALL

Designed by Sir Roger Pratt, whom Pevsner describes as 'the distinguished amateur architect – 1669-72', this was Pratt's own house. A hundred years later a young John Soane, having already had several commissions in Norfolk (Shotesham Hall, Letton Hall and Saxlingham Parsonage) made alterations including a remodelling of the elevations and alterations to the interior. A curious feature is the semi-basement arrangement of offices, the living rooms being on the first floor.

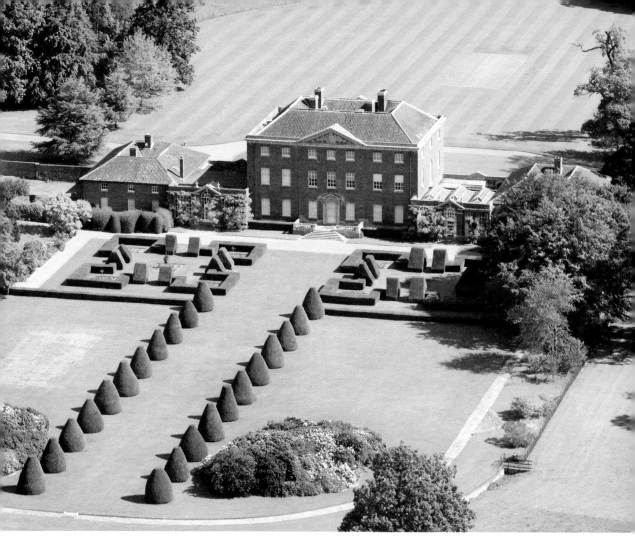

SALLE PARK

The Hall was built 1761- 3 and cost £2,470. Anne Boleyn's ghost is said to walk nearby.

The rear aspect of the house is as pleasing as the front.

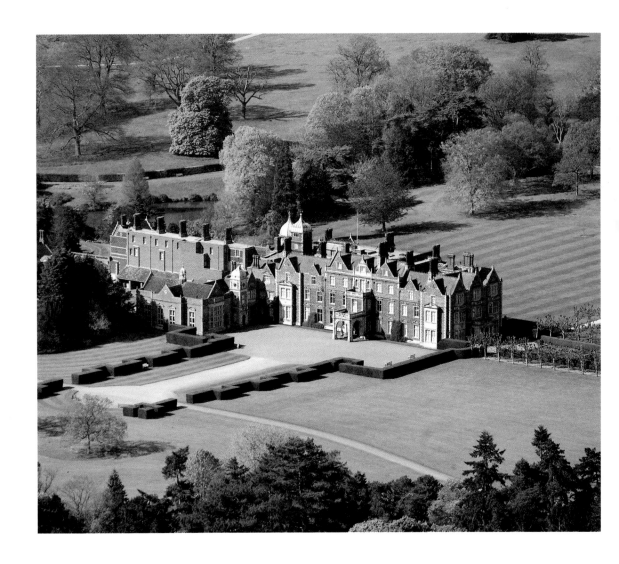

SANDRINGHAM HOUSE

The estate was bought in 1861 for £220,000 by the future Edward VII and alterations to the existing very large house were then executed by the little known architect A J Humbert. A fire of 1891 damaged the upper parts of the house and during repairs a second storey was added. Extravagant tall Tudor style chimneys were replaced by still tall but more restrained ones. In 1975 demolition of 91 rooms made the house more manageable.

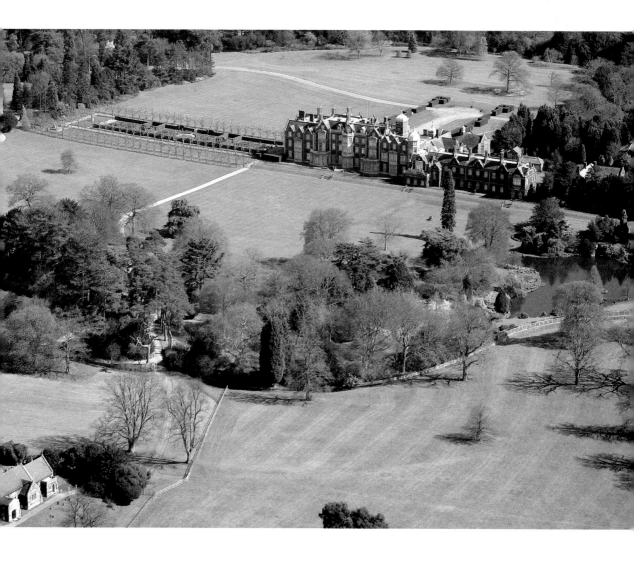

The mediaeval carstone of St Mary Magdalene church at Sandringham has a
Victorian interior containing gifts presented to royalty.

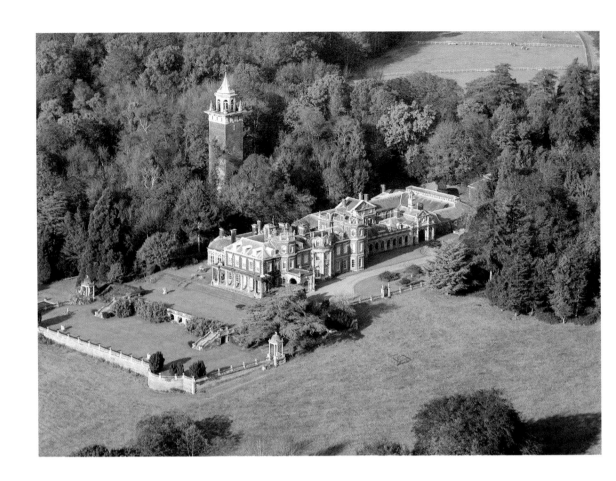

SENNOWE PARK

Sennowe Park at Guist was built 1908 by Norwich architect George Skipper and has been described as 'the last great country mansion in Norfolk'. Built for the grandson of Thomas Cook (of the travel firm) from a late 18th century house already on the site, Sennowe is described as 'having late classical inclinations in an imaginative and rich articulation of Edwardian design'. The 120 foot water tower, housing a belfry with chiming clock, makes a dramatic statement.

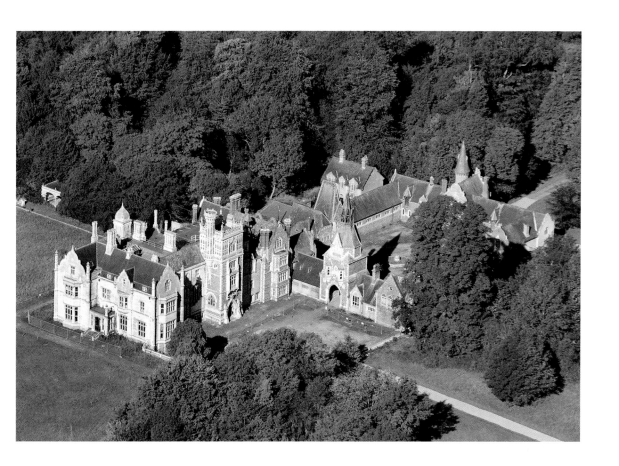

SHADWELL PARK

This is an extraordinary house remodelled from an earlier one of 1720. It is a typical example of the work of Victorian architect S.S.Teulon in 1857-60 containing Gothic features combined with intricate carved detail. Intentionally there is no symmetry whatsoever. One of the many quirky features is the stables' entrance arch, the tower is topped by an octagonal Early English style lantern. It is rare and refreshing when client and architect share a sense of fun.

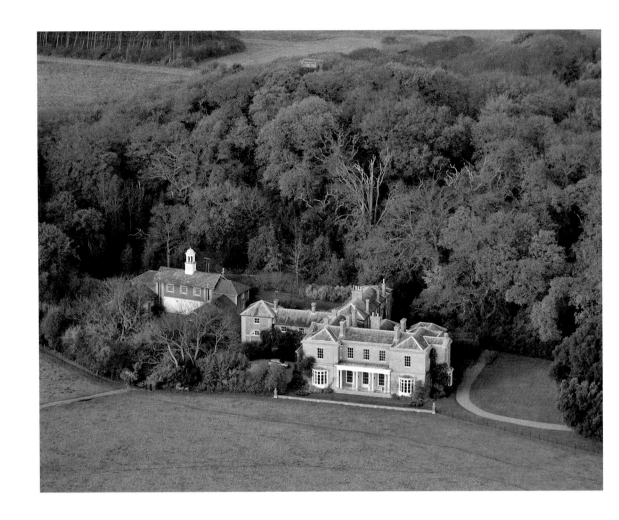

SHERINGHAM HALL

The Humphry Repton parkland of Sheringham Hall is now in the care of the National Trust It surrounds the house, sitting in a hollow about half a mile from the coast. This was the landscape designer's favourite work as detailed in his 'Red Book'. He produced a book for every project, bound in red leather, which he presented to each client. Repton's son John Adey Repton drew up the plans for the house built 1812-17 for Abbott and Charlotte Upcher.

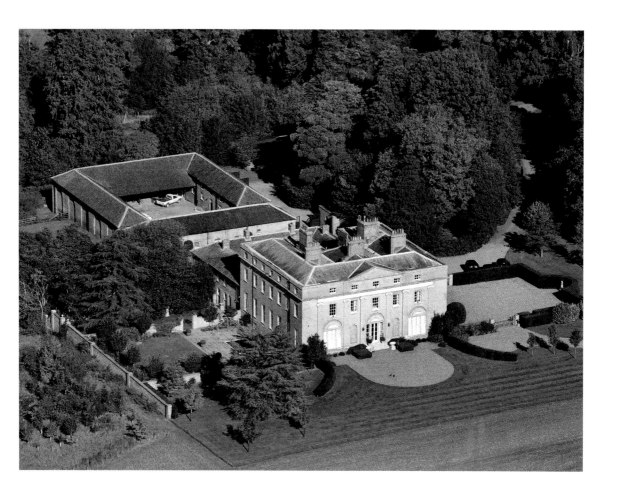

SHOTESHAM PARK

Built about 1785, it is described by Pevsner as 'A restrained, very beautiful building. Beige brick of the highest quality. Of subtle composition'. John Soane is remembered chiefly as being the architect of the Bank of England but in Norfolk alone his hand is apparent in many buildings, e.g. the stables and dovecote at Costessey Hall (now demolished), the gateway and lodges to Langley Hall, alterations to Earsham Hall, Ryston Hall and Burnham Westgate Hall, the interior of Taverham Hall, Letton Hall, and Norwich's Blackfriar's bridge.

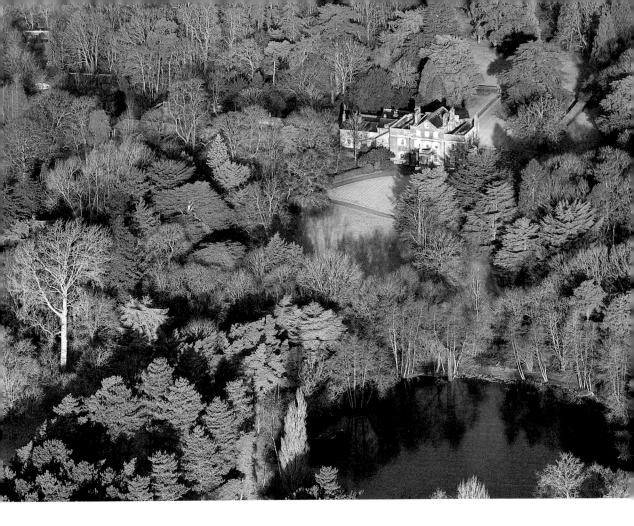

SHROPHAM HALL

Mary Mann (1848–1929) married a gentleman farmer and came to live at Shropham Hall. She was a social reformer who found poverty, degradation and brutality in the rural life. Her novels often reflected these conditions.

The house was completed in 1729 for John Barker who became High Sheriff of Norwich.

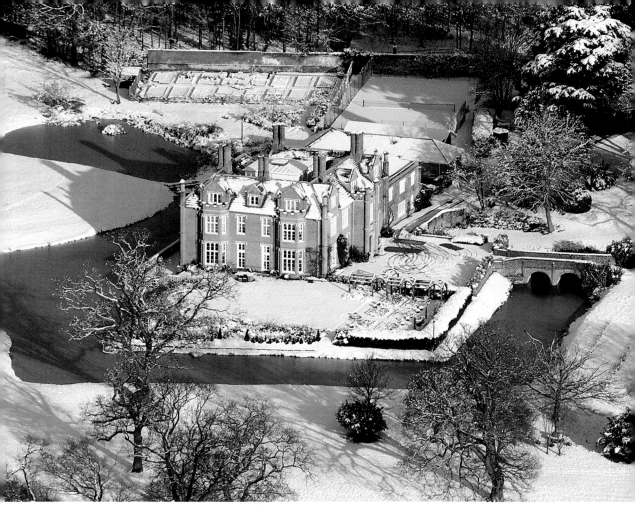

STANFIELD HALL

This house is remembered more for its grisly murder rather than for its architectural qualities. On the night of November 28 1848 the Recorder of Norwich, Isaac Jermy, and his son were shot dead at Stanfield Hall, their home. His wife and a female servant were wounded. Tenant farmer James Rush was apprehended and hanged.

Dating from 1792 and by William Wilkins – architect of Norwich Shire Hall, Brooke Hall and the Theatre Royal, Great Yarmouth – it is 'Tudorised ' externally.

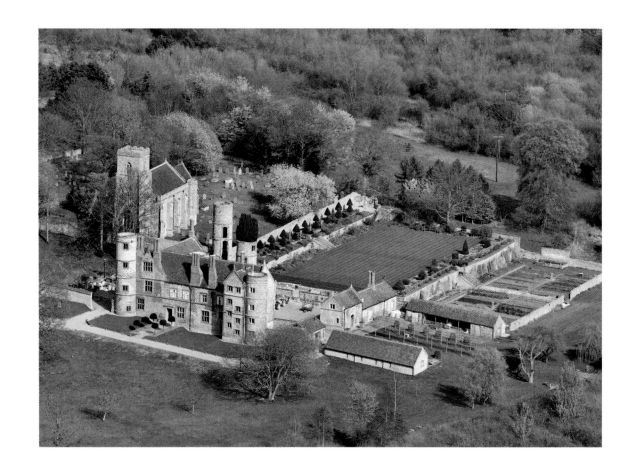

STIFFKEY HALL

Stiffkey Hall is an exciting looking building, built by the Bacon family in the 16th century. Only part of it remains, built of flint with brick dressings. In recent years it has undergone considerable renovation.

The journals of Nathaniel Bacon of Stiffkey Hall (1546–1622) provide much information on life in north Norfolk at that time. They are gradually being published in a series by the Norfolk Record Society, with five volumes being available at the time of writing.

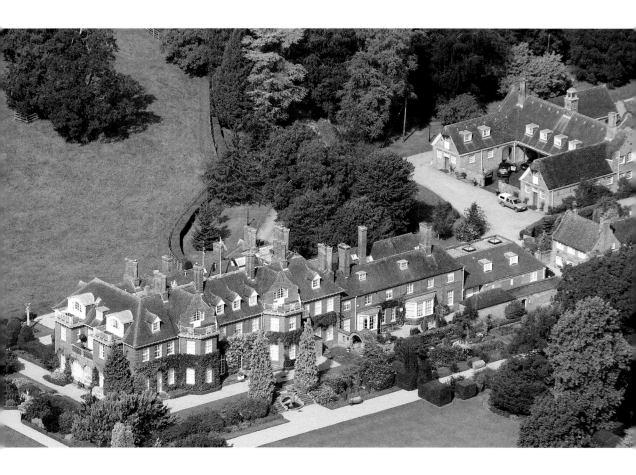

SOUTH PICKENHAM HALL

This is one of the modern grand houses of Norfolk. It replaced one built only 70 years earlier by Donthorn, architect of Cromer Hall. It was built in 1903 by Scotsman Robert Weir Schultz, himself part of the Arts and Crafts movement which included Edward Boardman of How Hill.

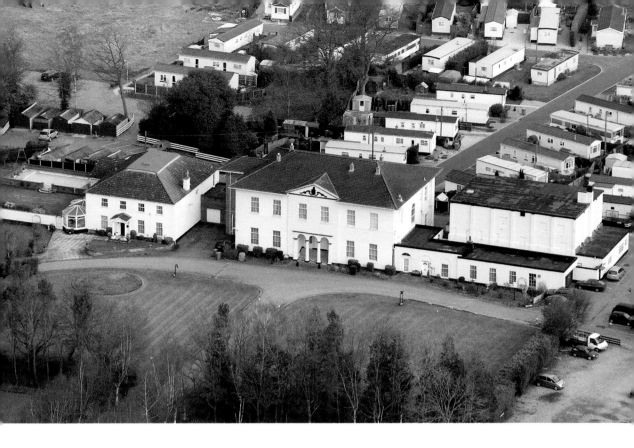

STRATTON STRAWLESS HALL

The name Stratton Strawless is a corruption of Stratton Streles. The hall was built around 1800 for the Marsham family from the nearby village bearing their name. The gardens had already been designed and drew compliments from the great landscape designer Humphry Repton – one wonders whether he would have been equally complimentary about the landscape of prefabricated homes which now surround the hall. Rather than demolish the whole of the hall as seems to have been the usual practice (Norfolk is littered with piles of rubble which were once grand country houses) the top storey was removed in the 1960s. In its prime the hall was said to have had 32 bedrooms and stabling for 30 horses.

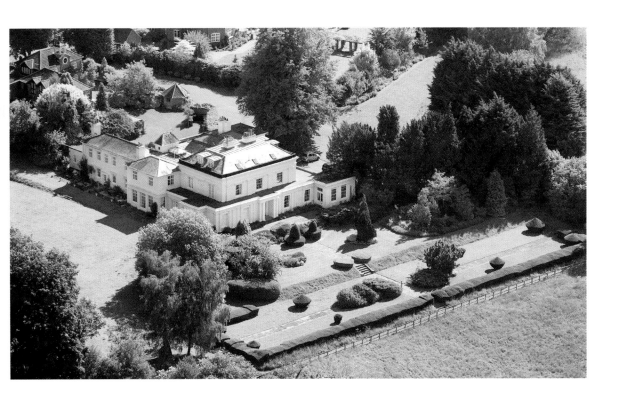

THICKTHORN HALL

The delightfully named Thickthorn Hall has been owned in turn by two prominent Norfolk industrialists Colman's of mustard fame and Macintosh, confectioners. An early 19th century stuccoed house it is now converted into flats and the name lives on more because of the recent Thickthorn interchange of the A11 and A 47 and the nearby Park and Ride terminus. How the mighty have fallen.

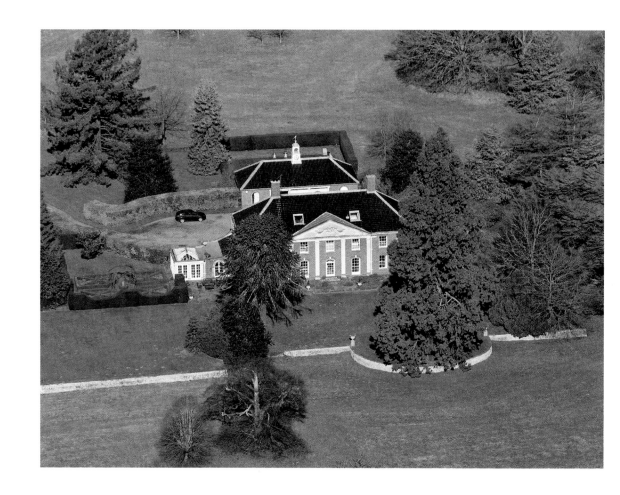

WATLINGTON HALL

The house was rebuilt after a fire in the 1940s. It stands on the site of the previous hall (1797).

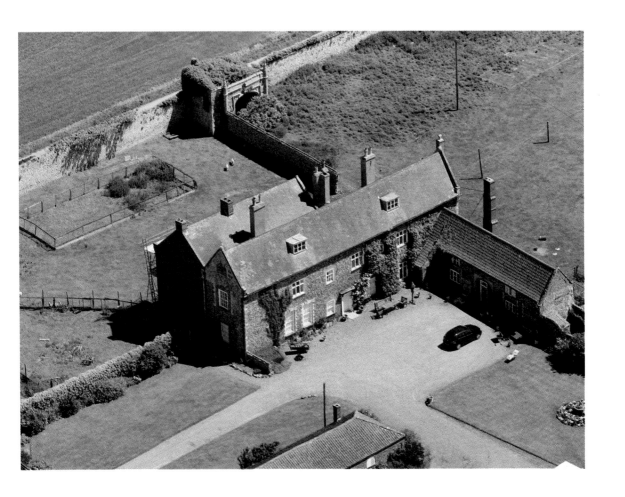

WAXHAM HALL

Built probably in the last quarter of the 16th century in its early days the knapped flint dwelling was a baronial hall lived in by succeeding generations of the Brograve family who farmed the land. Brograve Drainage Mill stands by Waxham New Cut which drains into Horsey Mere. The Hall was probably built contemporaneously with Waxham Great Barn, one of the longest in the county.

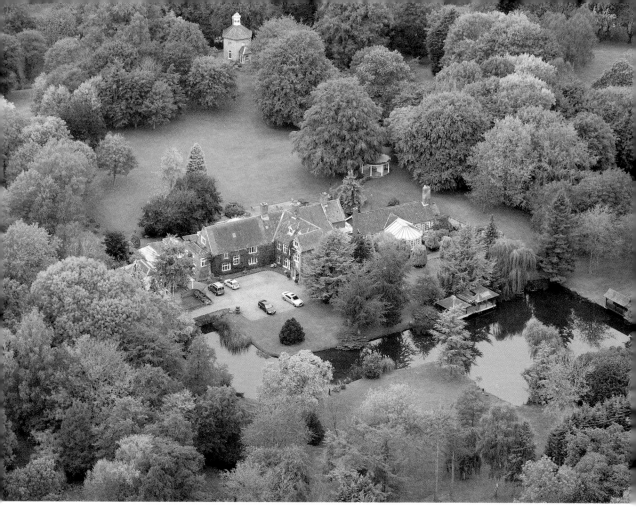

WESTON LONGVILLE, OLD HALL

Weston Longville will always be associated with the 18th century parson James Woodforde who served in the parish 1774-1803 rather than with this house. The water (foreground) is possibly part of the moat of the original house.

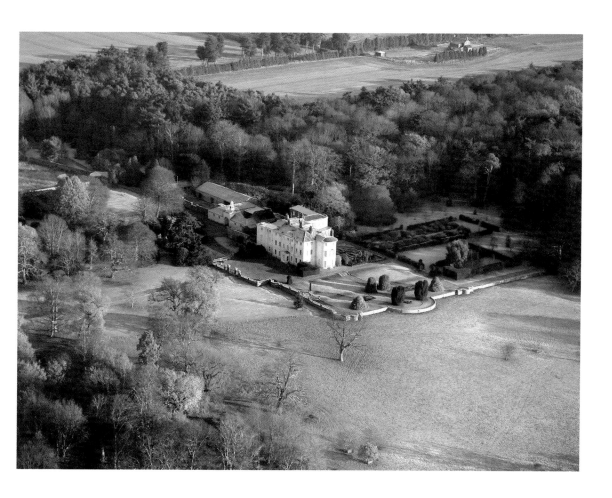

WESTWICK HOUSE

There is some debate about the date the house was built. Pevsner says around 1800 which seems more likely than the 1700 quoted elsewhere

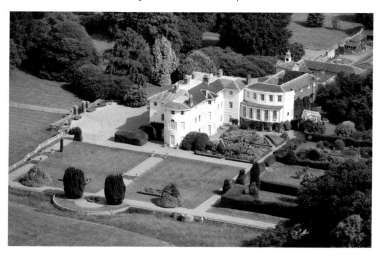

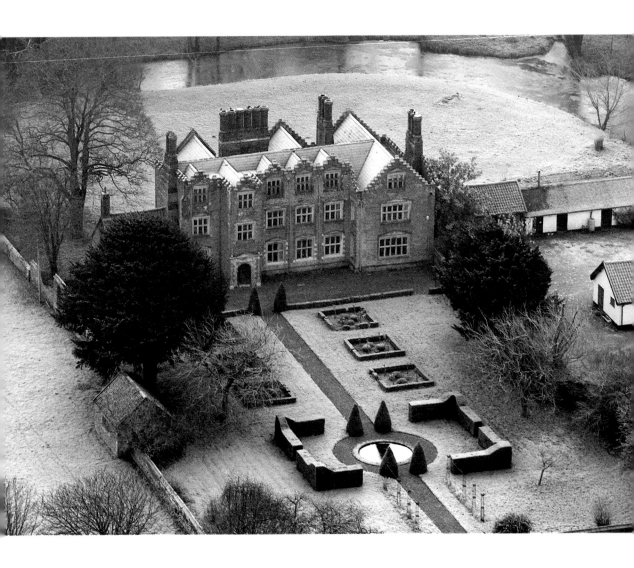

WILBY HALL

An Elizabethan Hall of the mid 1600s and from the picture possibly moated although there are no references to one.

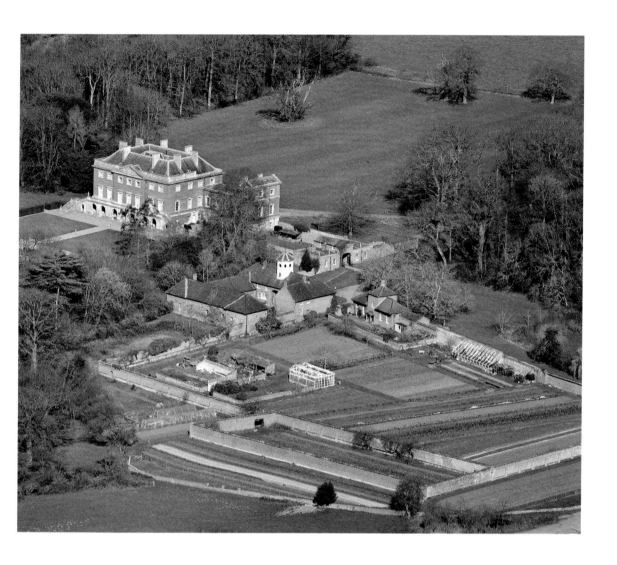

WOLTERTON HALL

It was built in the years 1727-41 for Horatio Walpole, brother of England's first Prime Minister ,Robert of Houghton Hall. It is described as 'of beautiful rosy brick above a ground floor of Portland stone' . The choice of Portland stone is unusual in Norfolk.

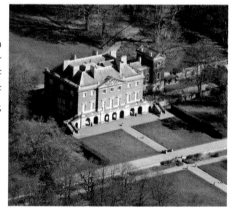

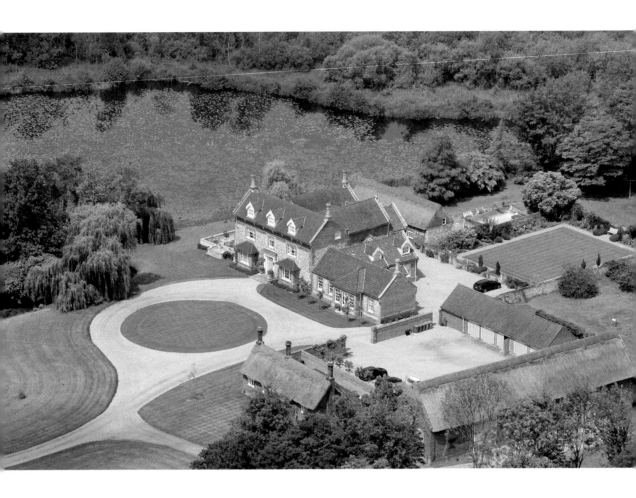

WOODBASTWICK OLD HALL

The original hall dating from 1600 was rebuilt circa 1803 following a fire It was demolished in 1971 and rebuilt once more in 2004. The village of Woodbastwick has a charming 'feudal' appearance with thatched cottages grouped round a well on the village green.

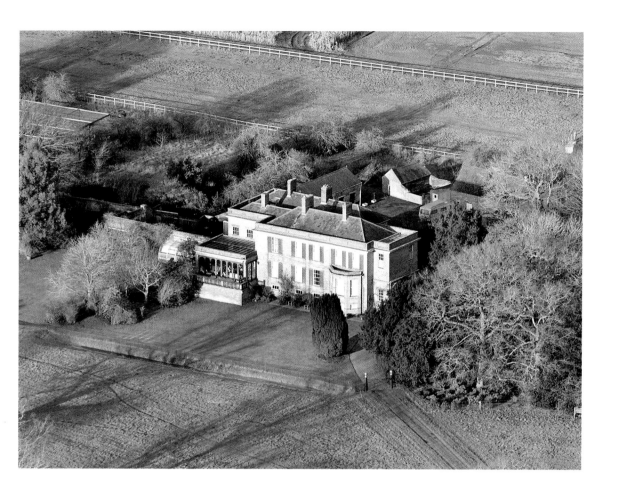

WRAMPLINGHAM HALL

And so we conclude this title with a view of the hall at Wramplingham with the long shadows of a late December morning.

Bibliography

Clarke, David *The Country Houses of Norfolk: The Major Houses* Clarke 2006

Clarke, David *The Country Houses of Norfolk: The Lost Houses* Clarke 2008

Dixon, R and Muthesius, S *Victorian Architecture* Thames and Hudson 1978

Dymond, David *The Norfolk Landscape* Alastair 1990

Edwards, Derek and Williamson, Tom *Norfolk Country Houses from the Air* Sutton, 2000

Harrod, Wilhemine *The Norfolk Guide* Alastair Press 1988

Norfolk Heritage Explorer, www.heritage.norfolk.gov.uk/home (accessed 27th August 2015)

Pevsner, Nikolaus *The Buildings of England Norfolk: North West and South* Penguin

Pevsner, Nikolaus *The Buildings of England Norfolk: North East and Norwich* Penguin

Pocock, Tom *Norfolk* Pimlico 1995

Service, Alastair *Edwardian Architecture* Thames and Hudson 1977

Wade Martins, Susanna *A History of Norfolk* Phillimore 1997

White's Norfolk 1845 David and Charles 1969

Winkley, George *The Country Houses of Norfolk* Panda 1986 Chatfield, Mark

Index